C000153897

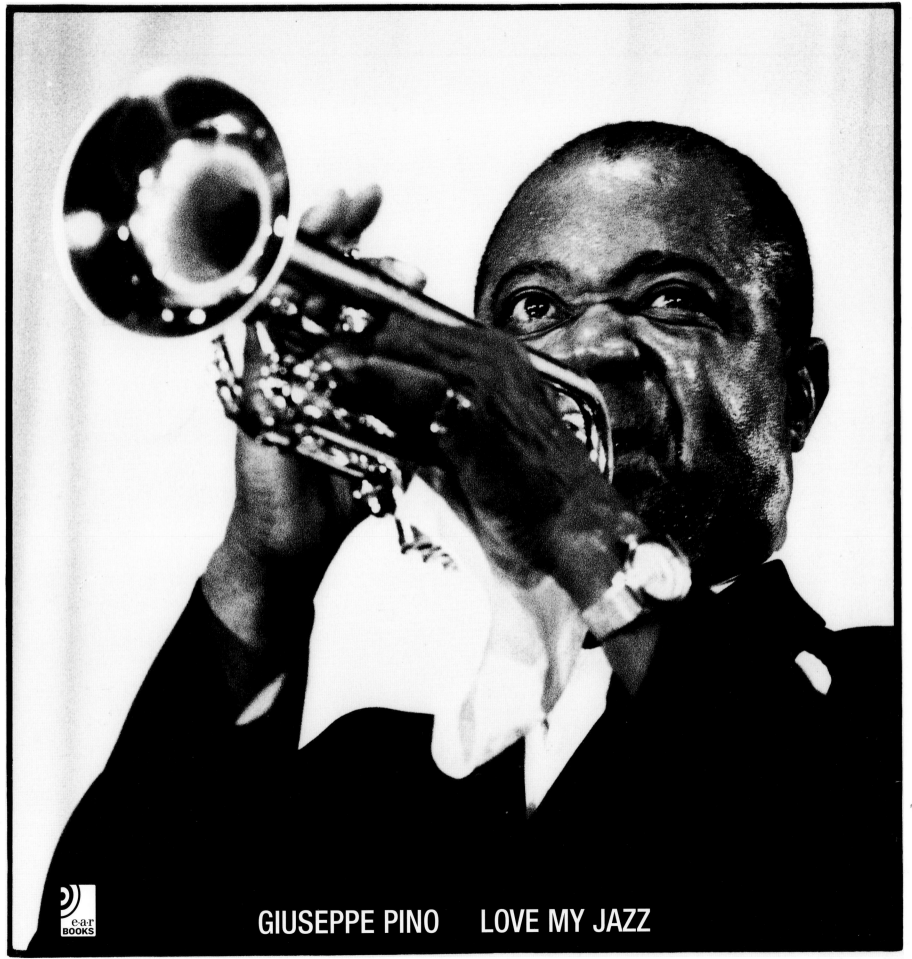

GIUSEPPE PINO LOVE MY JAZZ

Louis Armstrong, 1967

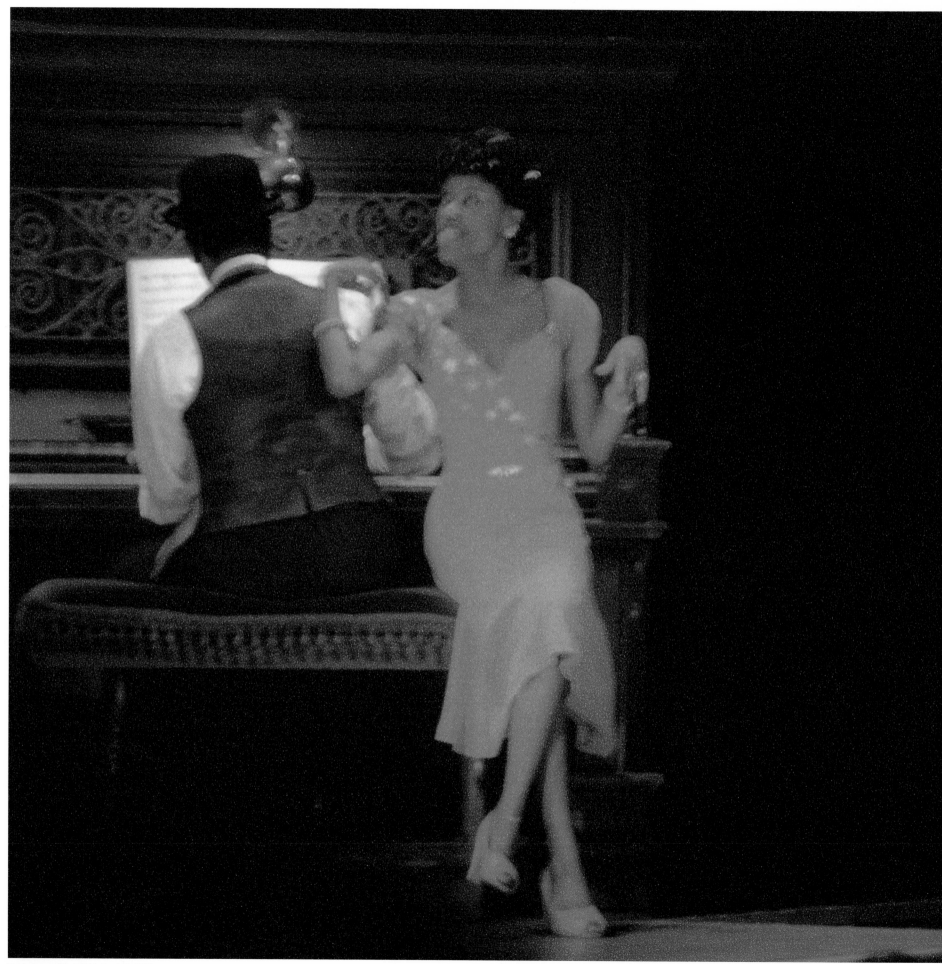

Hank Jones, "Ain't Misbehavin", 1979

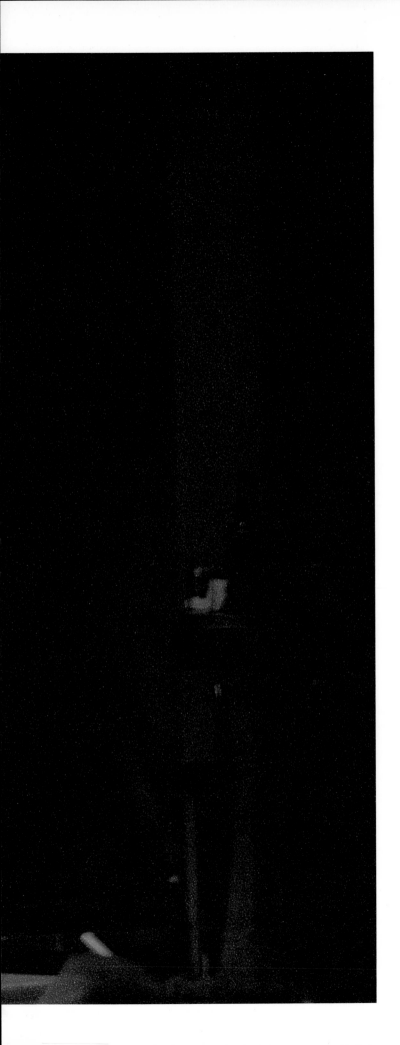

Thanks to Bruno, Barbara, Chiara

ISBN 3-937406-00-X

Graphics and cover by Guido Scarabottolo

Produced by **optimal** GmbH, Röbel/Germany
Printed and manufactured in Germany

EarBooks is a project of

www.earbooks.net

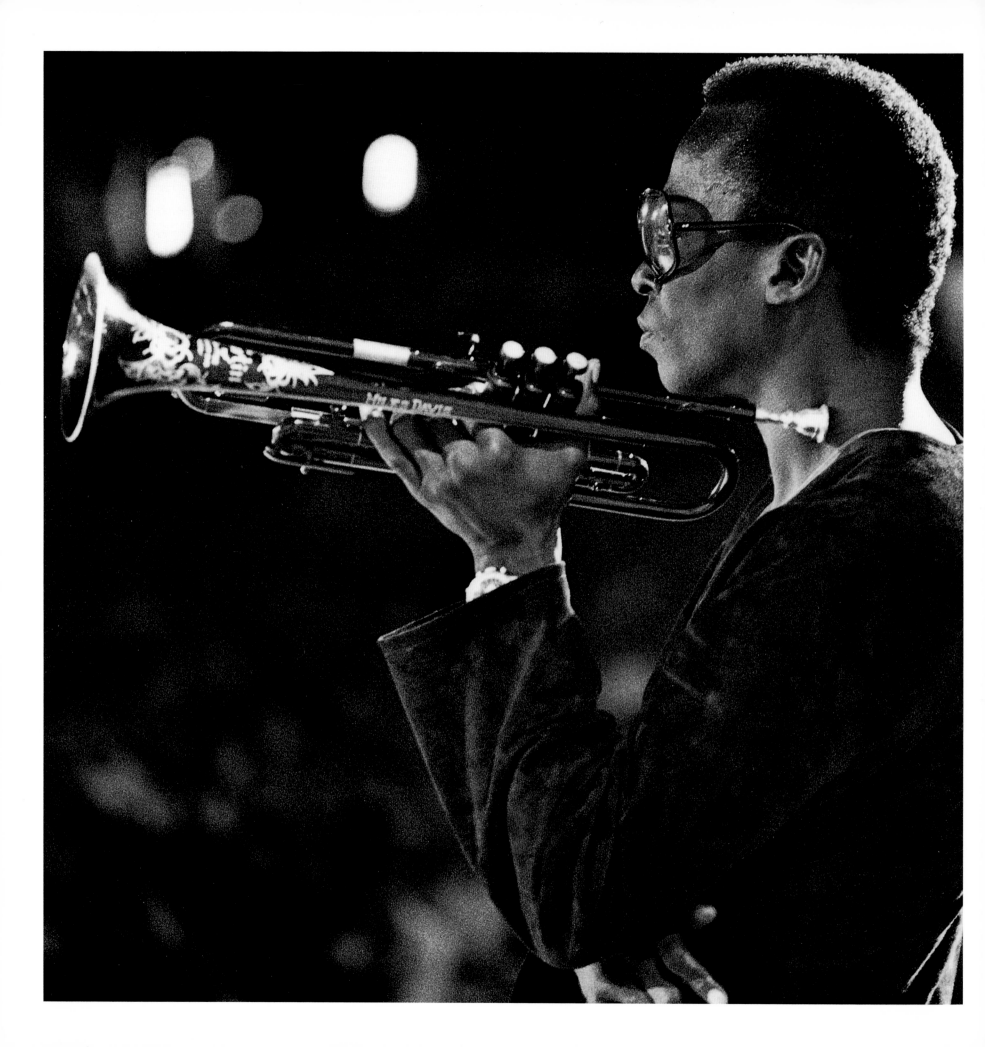

Miles Davis, 1969, 1971

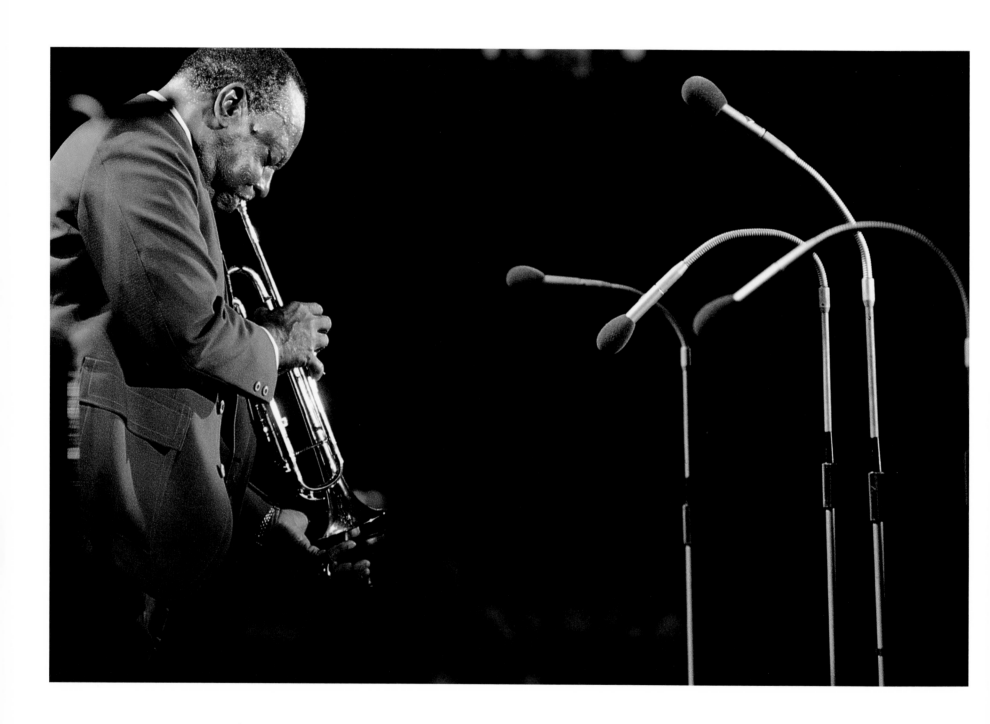

Coatie Williams, 1976

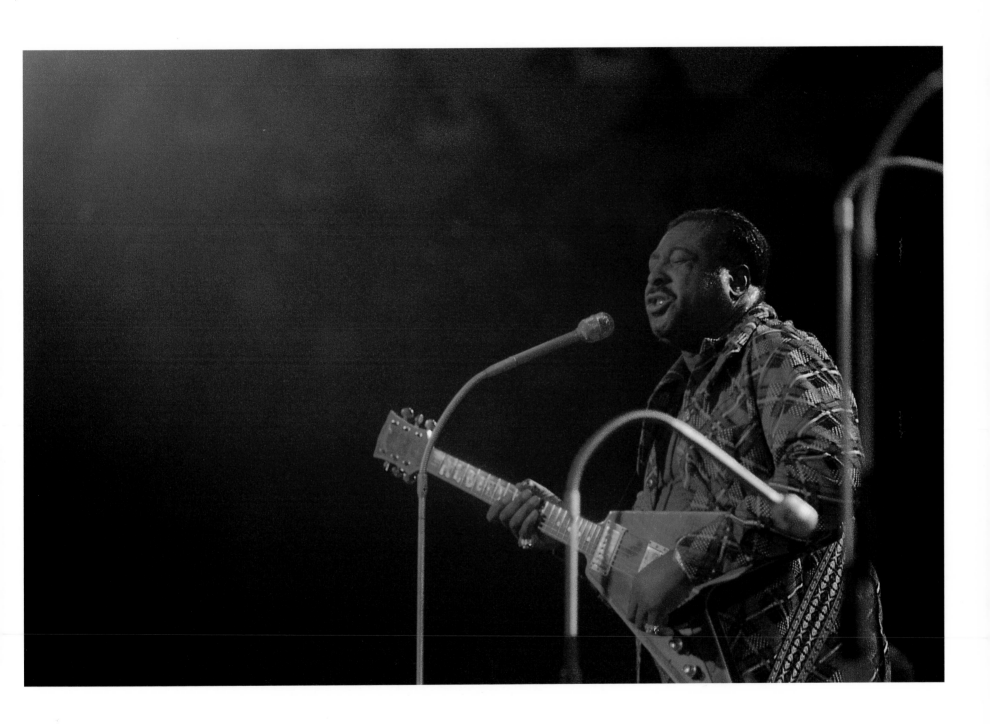

Albert King, 1975

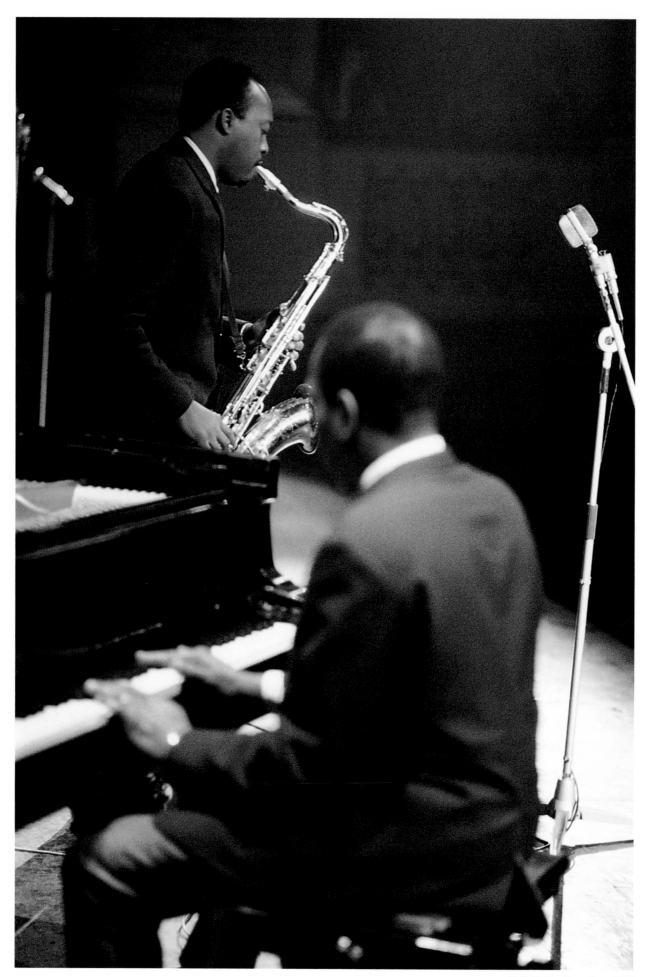

Hank Mobley, Kenny Drew, 1968

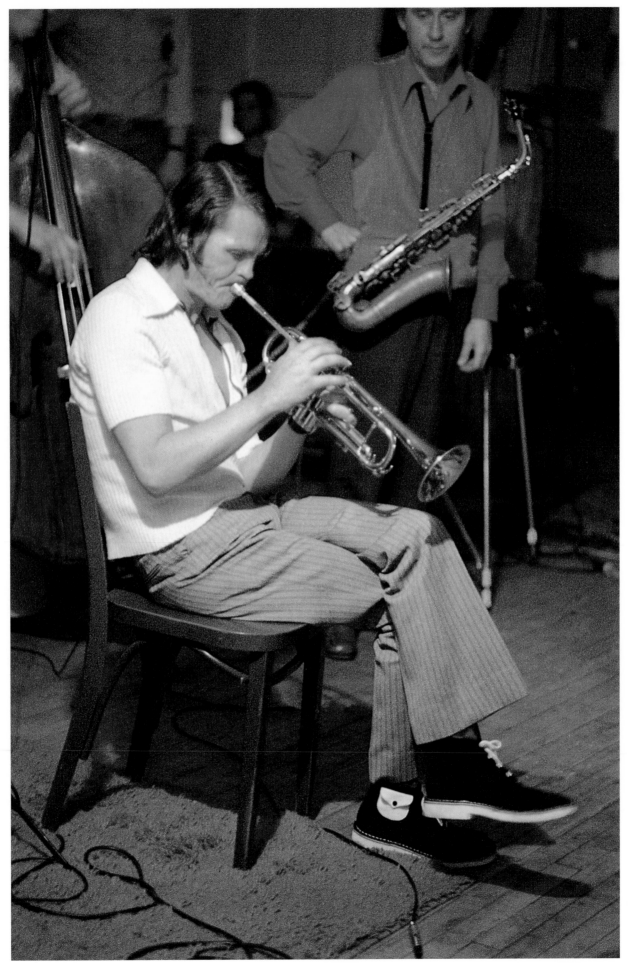

Chet Baker, Lee Konitz, 1968

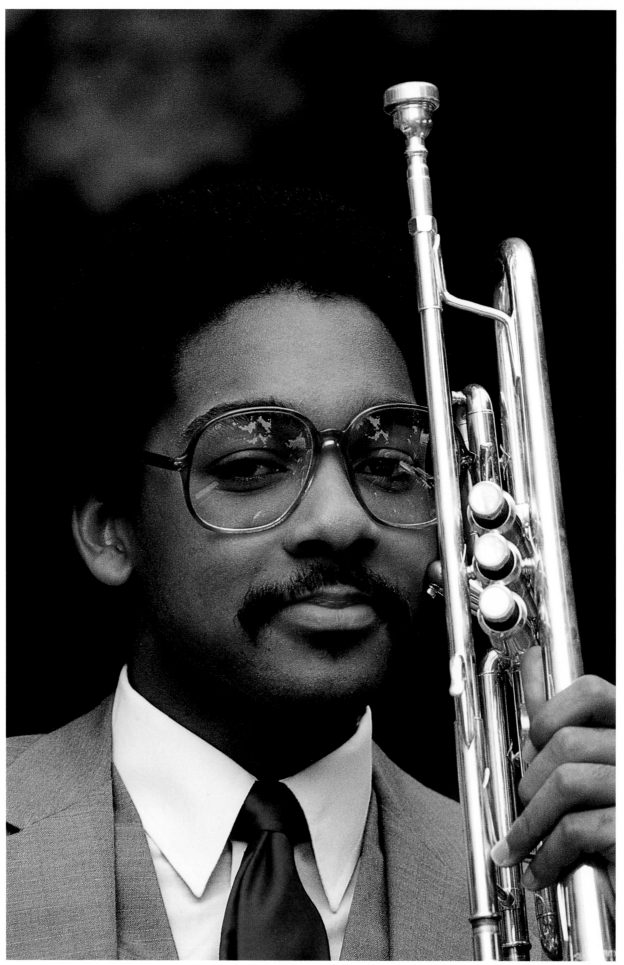

Wynton Marsalis, 1978

Paolo Fresu, Enrico Rava, 2000

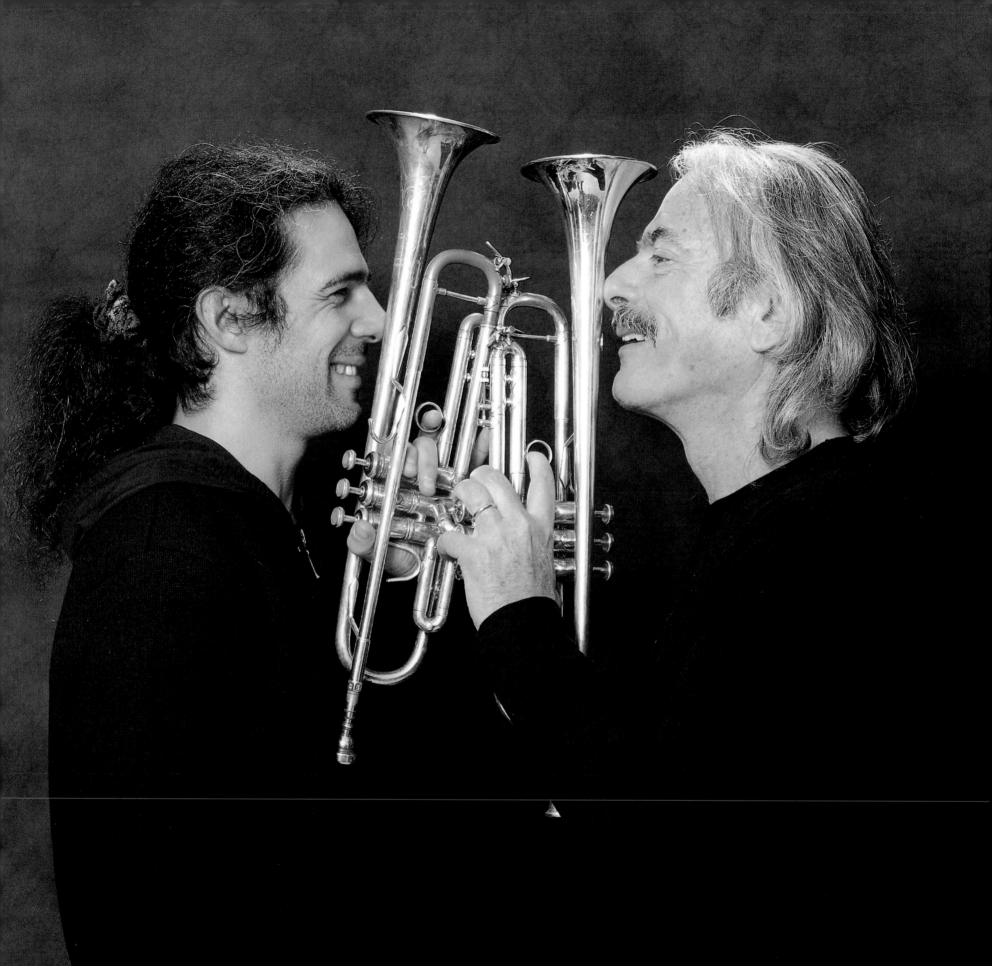

Ben E. King, 1977

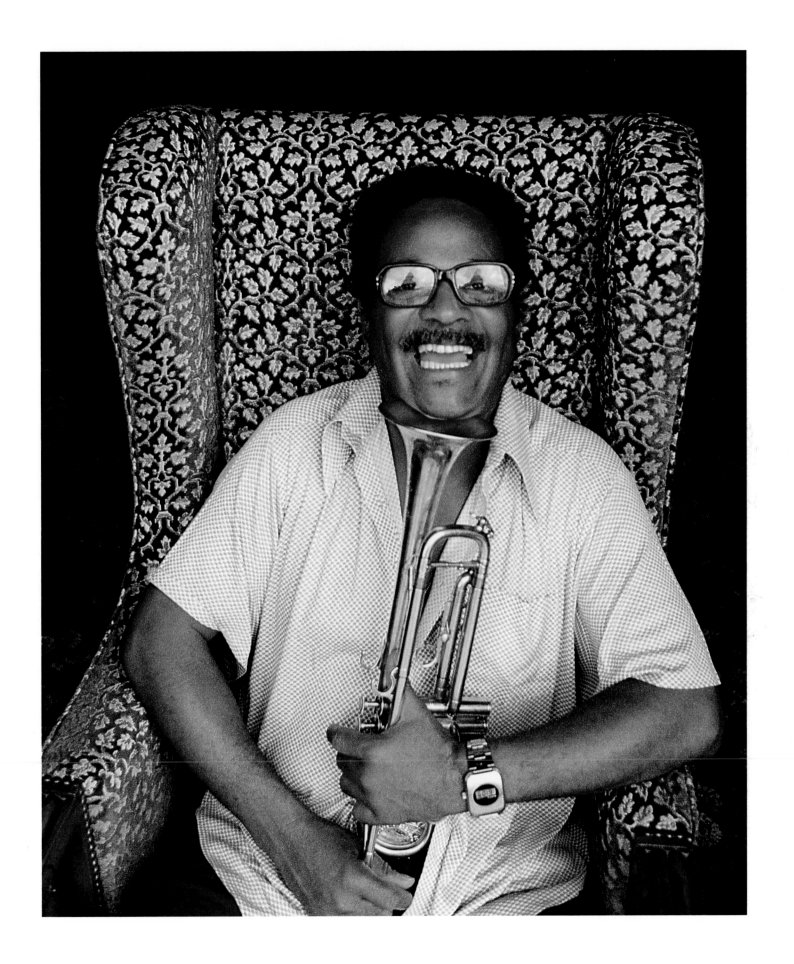

Clark Terry, 1975

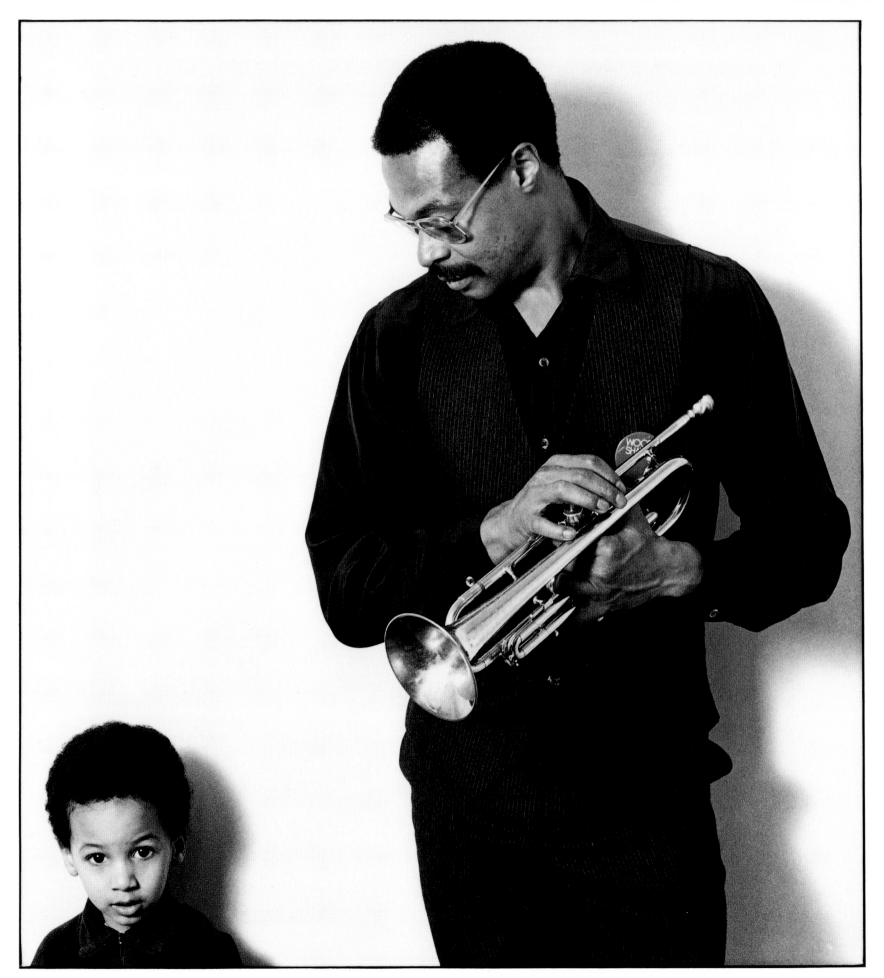

Woody Shaw, 1981

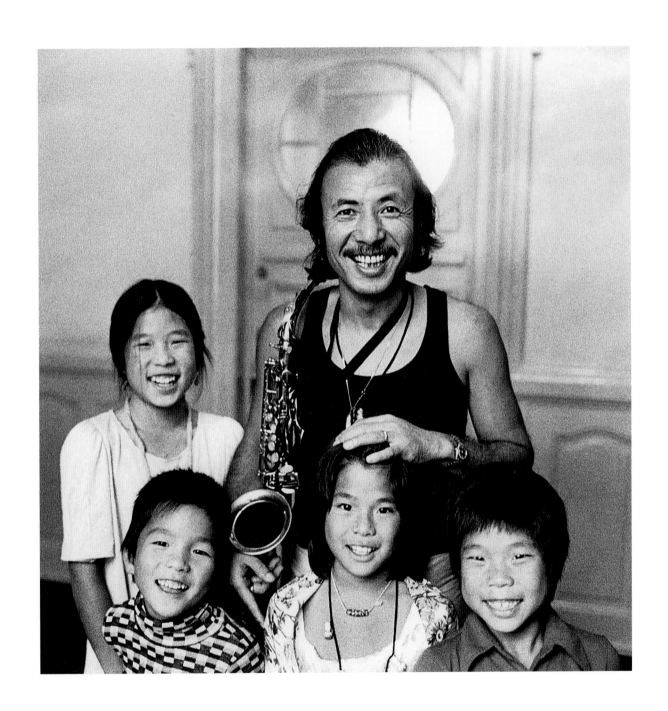

Sadao Watanabe, 1975

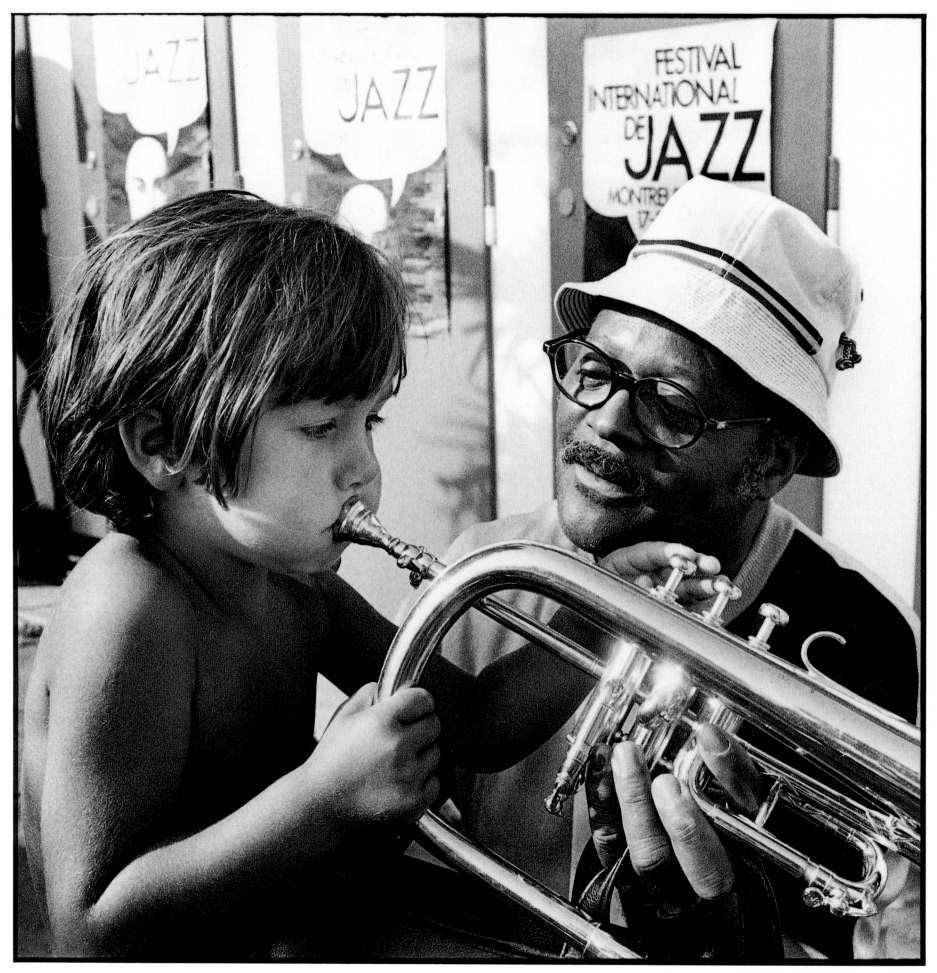

Clark Terry, 1975

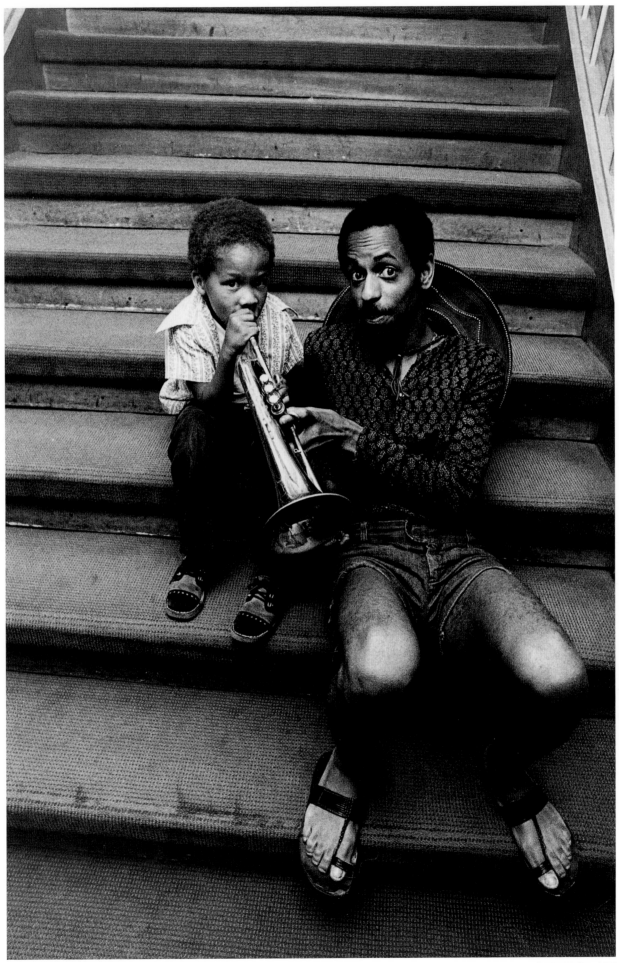

Charles McGee, 1973

Leroy Jenkins, 1976

Don Cherry, 1973

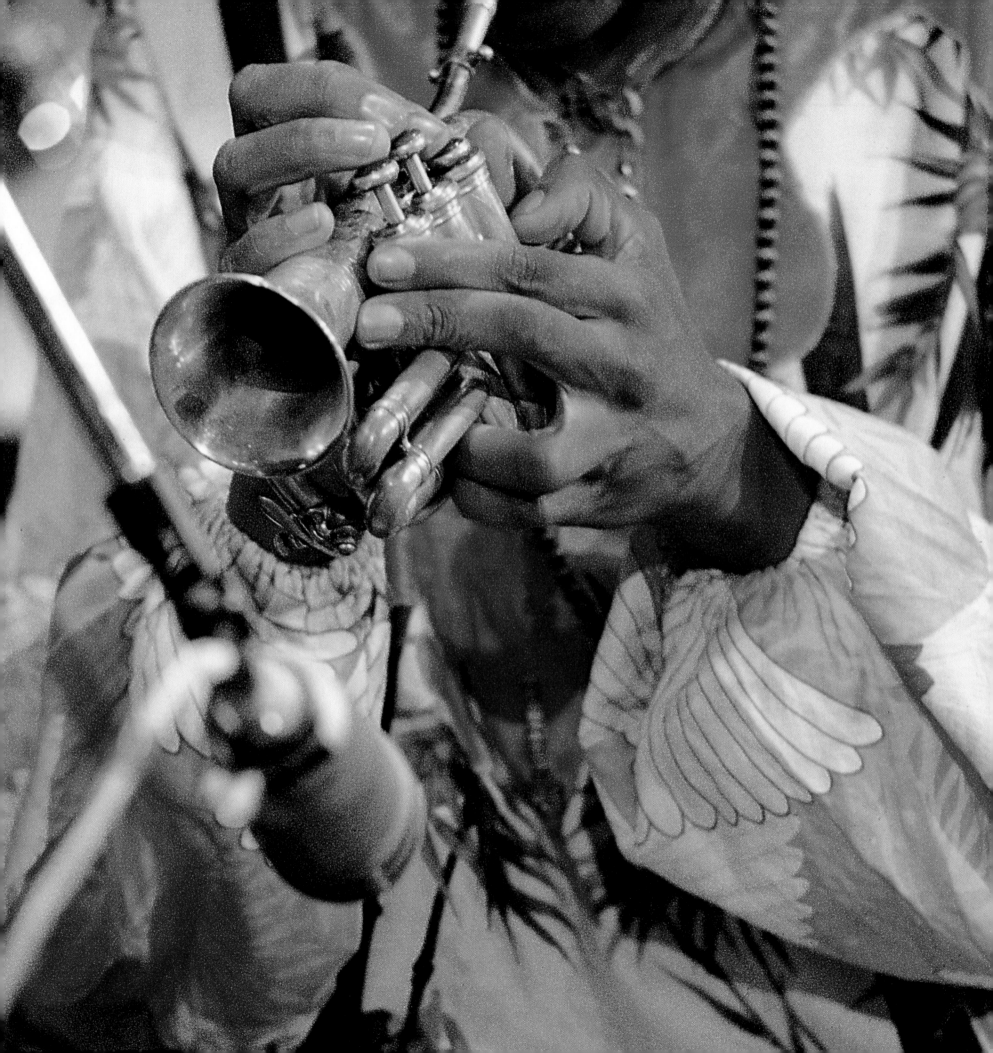

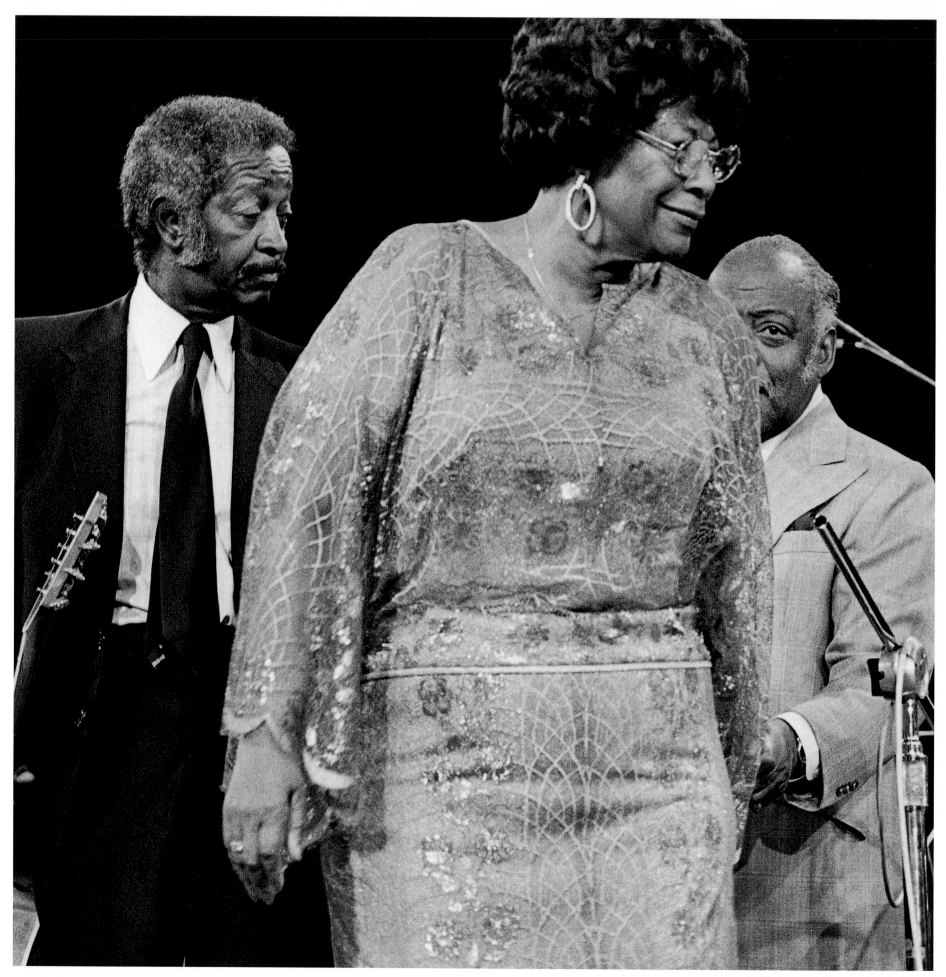

Freddie Green, Ella Fitzgerald, Court Basie, 1979

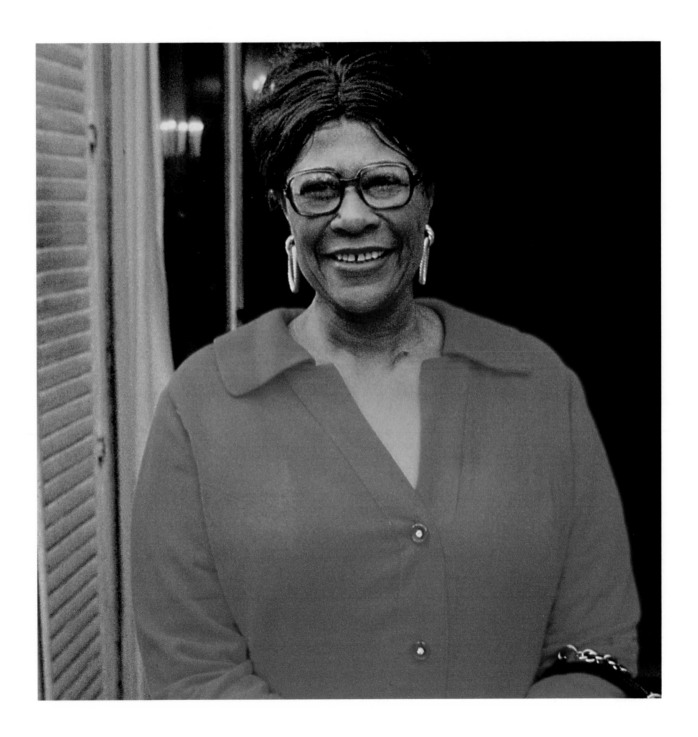

Ella Fitzgerald, 1972

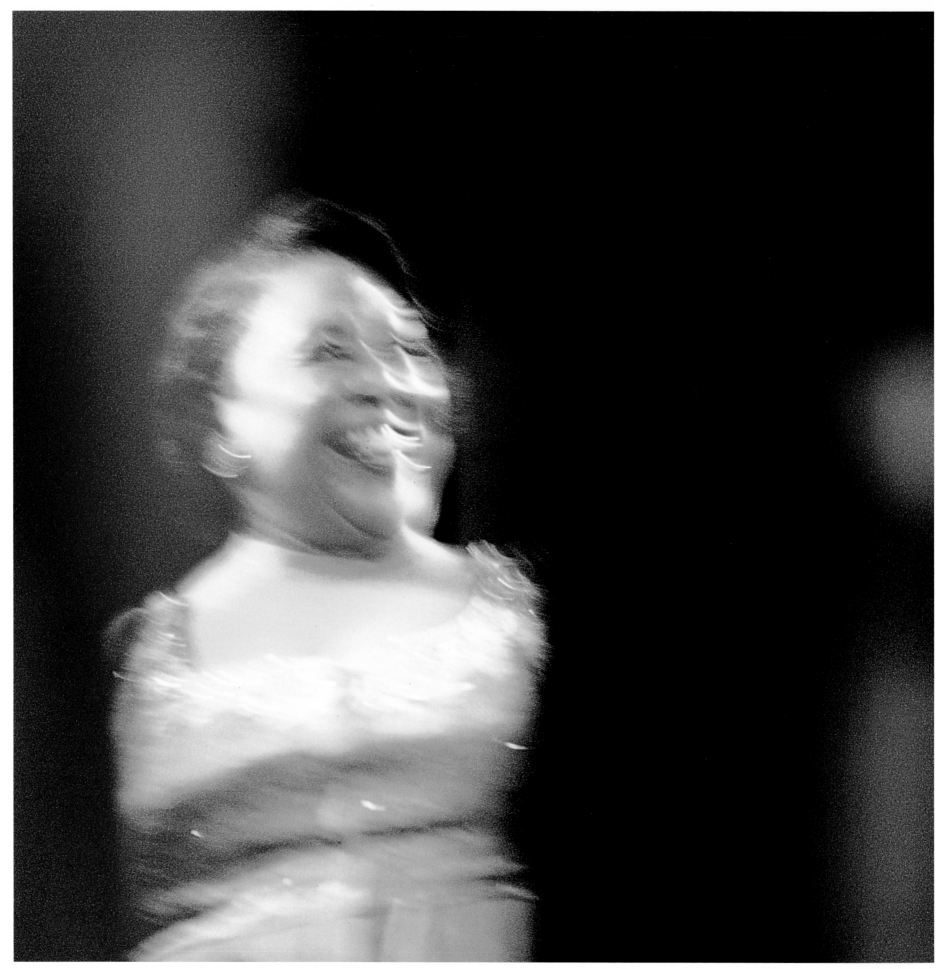

Helen Humes, 1974

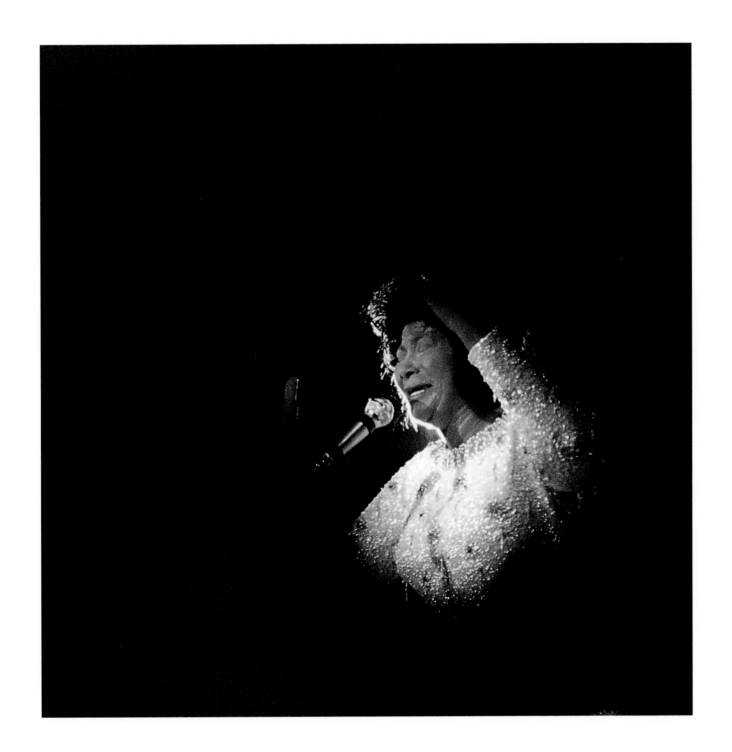

Mahalia Jackson, 1968

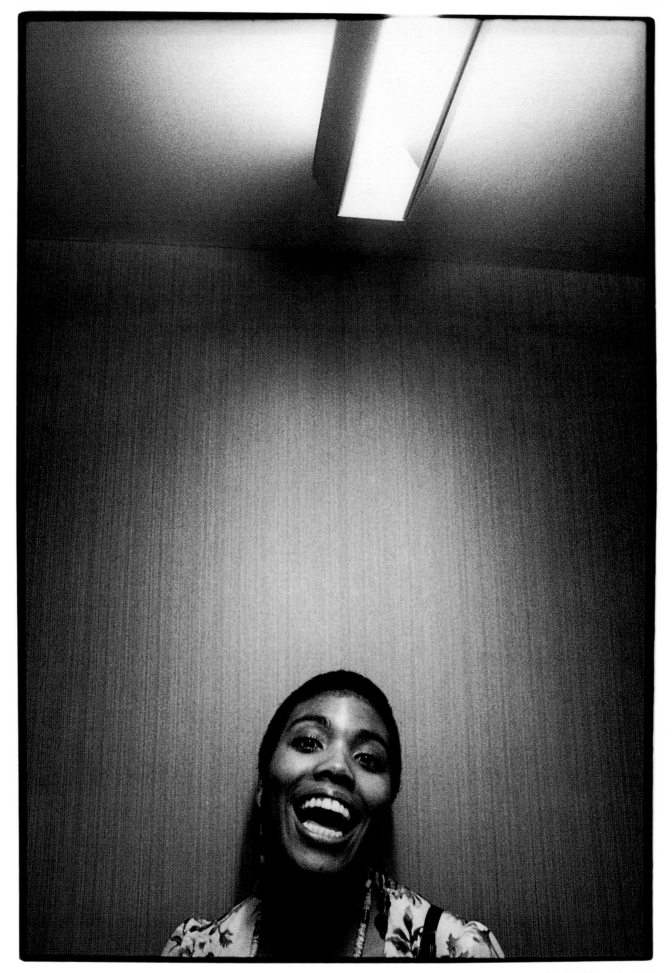

Dee Dee Bridgewater, 1974

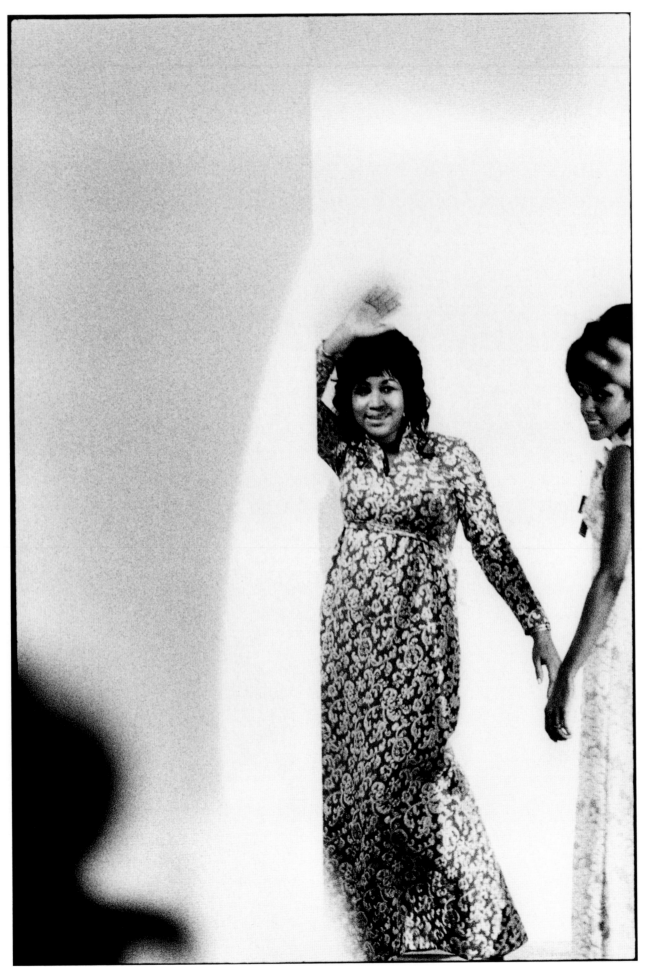

Aretha Franklin, 1968

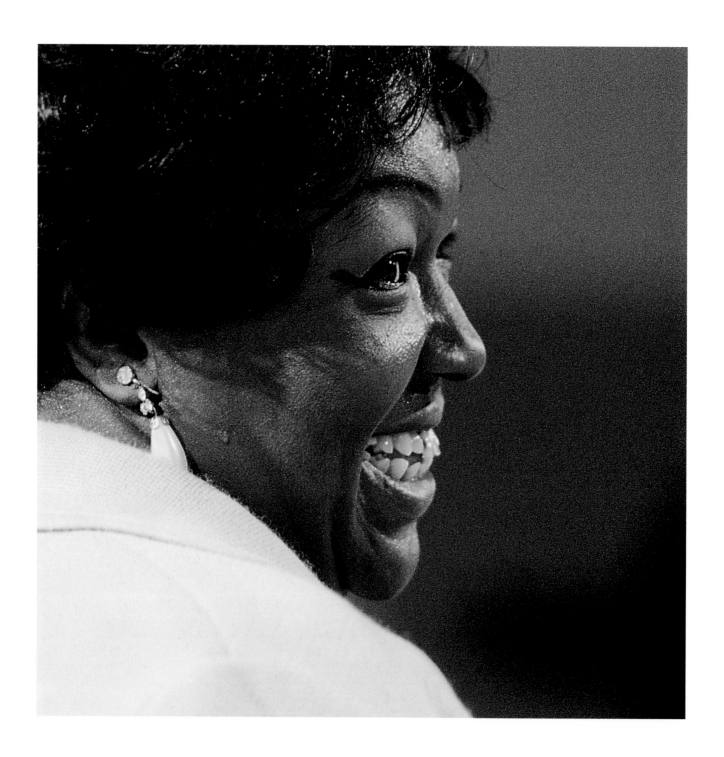

Bessie Griffin, 1972

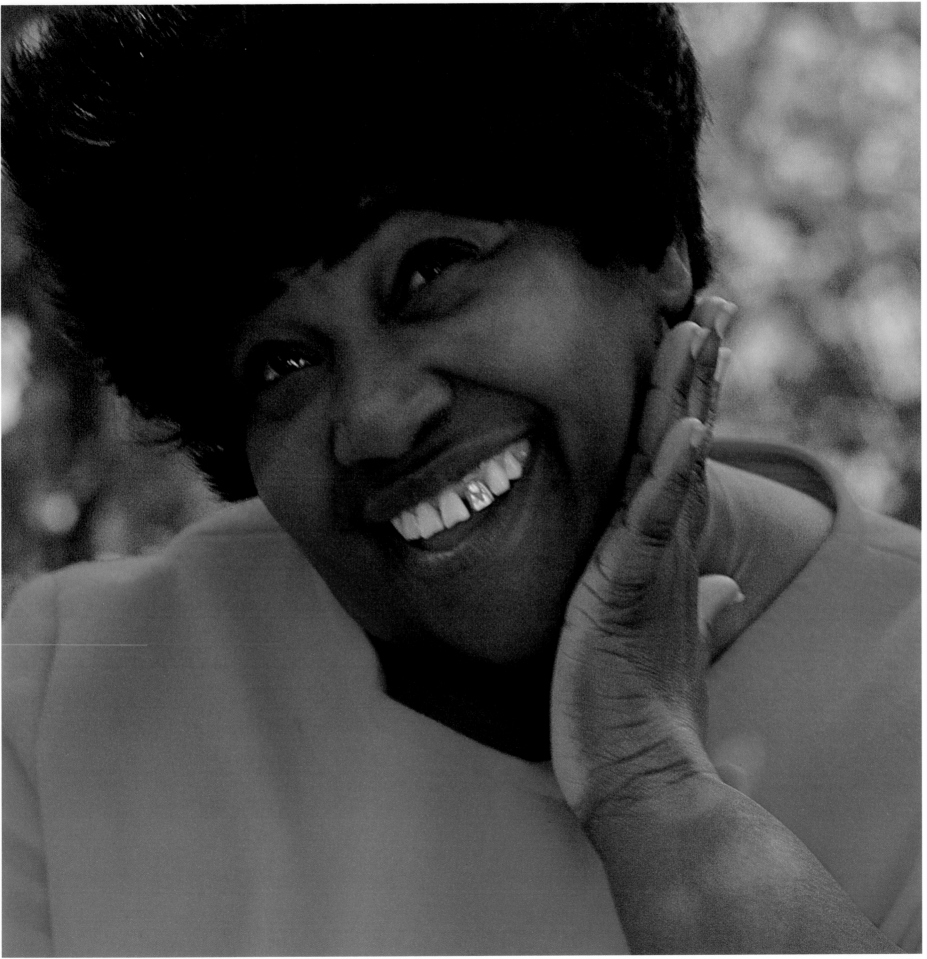

Marion Williams, 1969

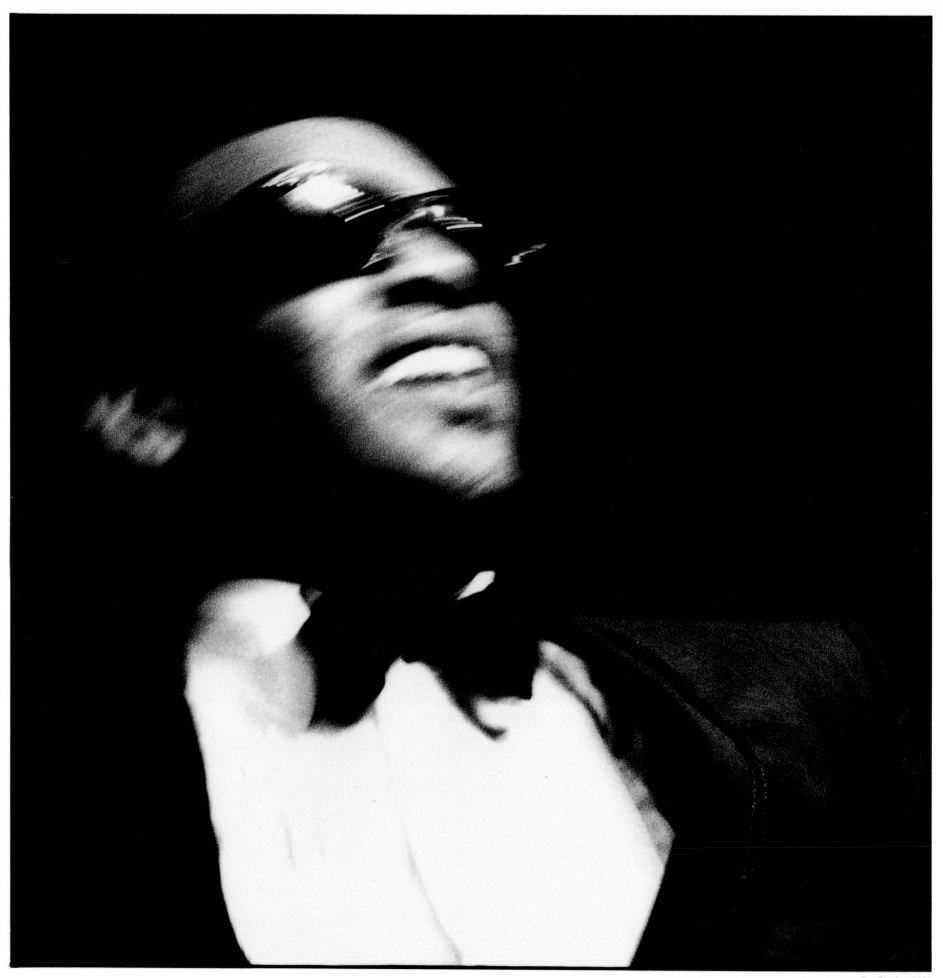

Ray Charles, 1969

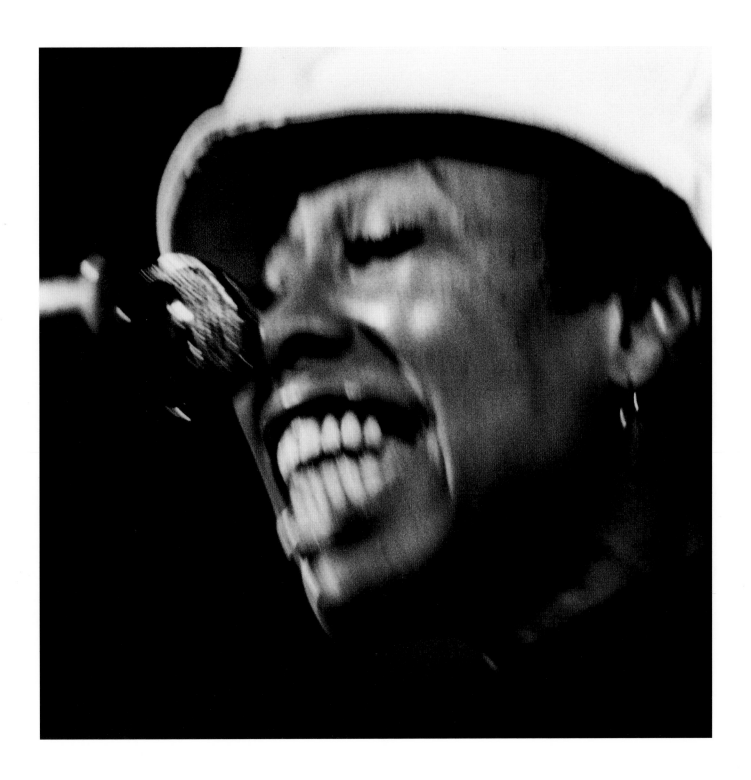

Betty Carter, 1968

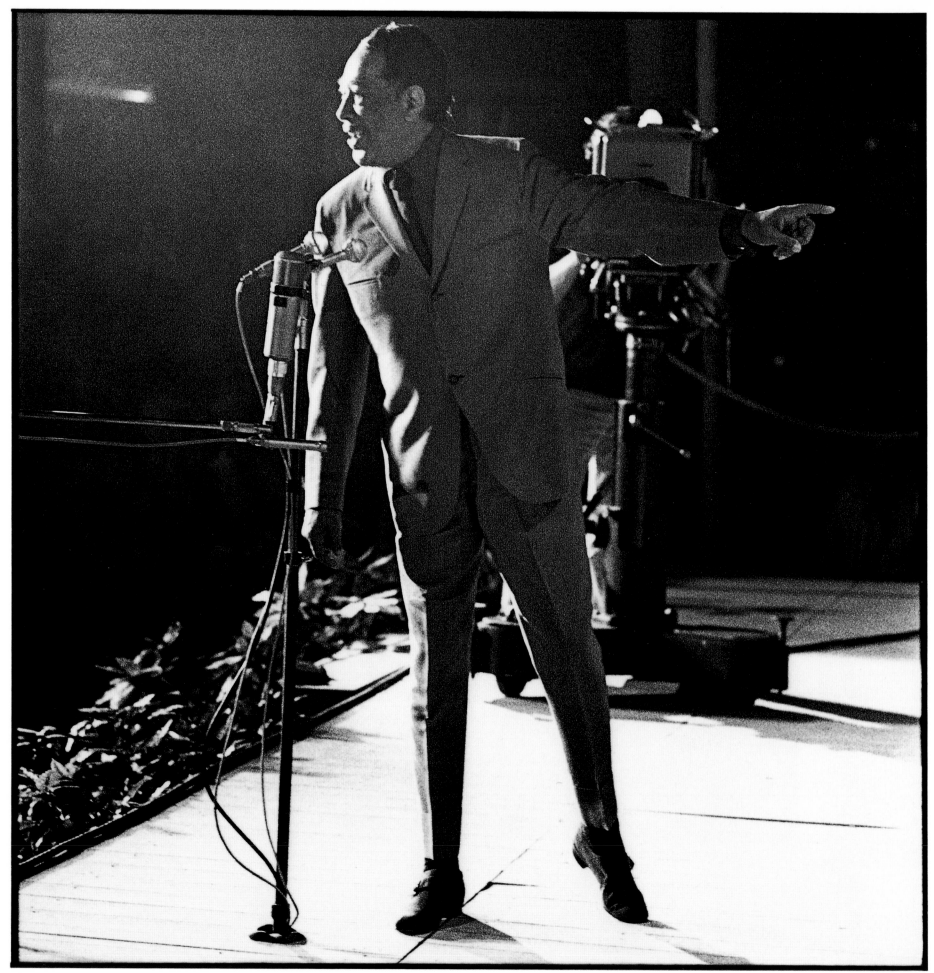

Duke Ellington, 1966

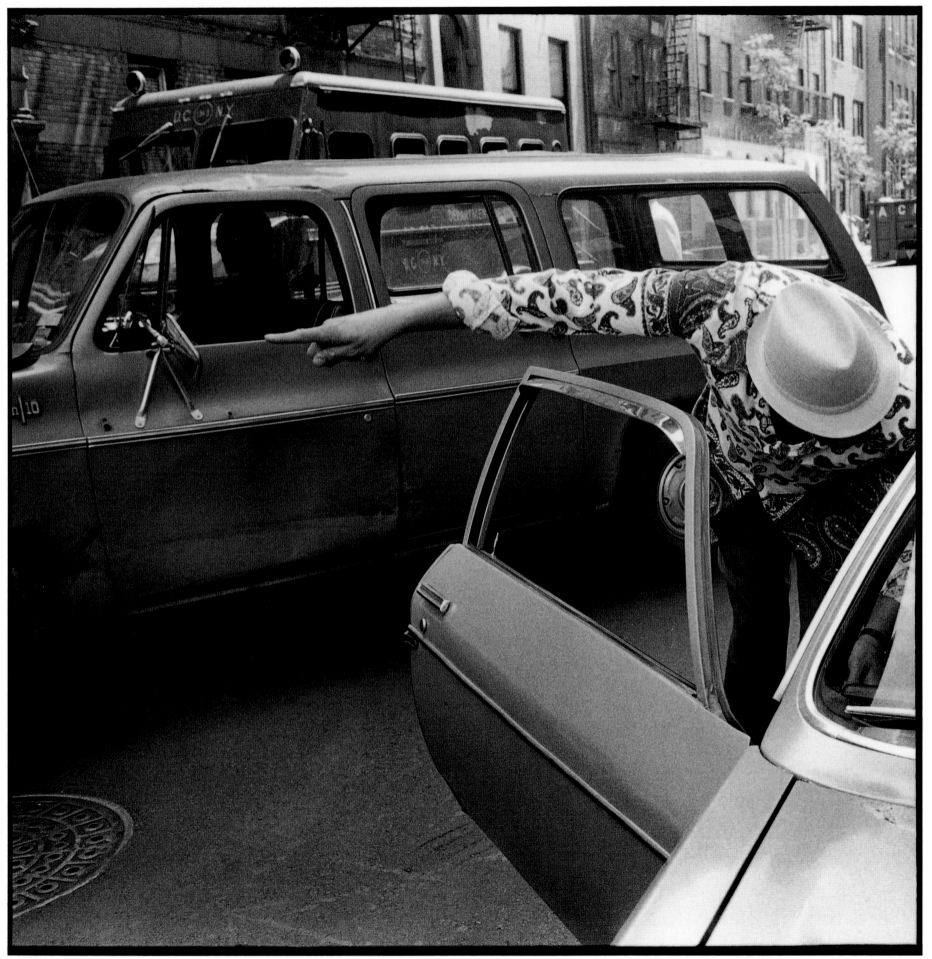

Dexter Gordon, 1984

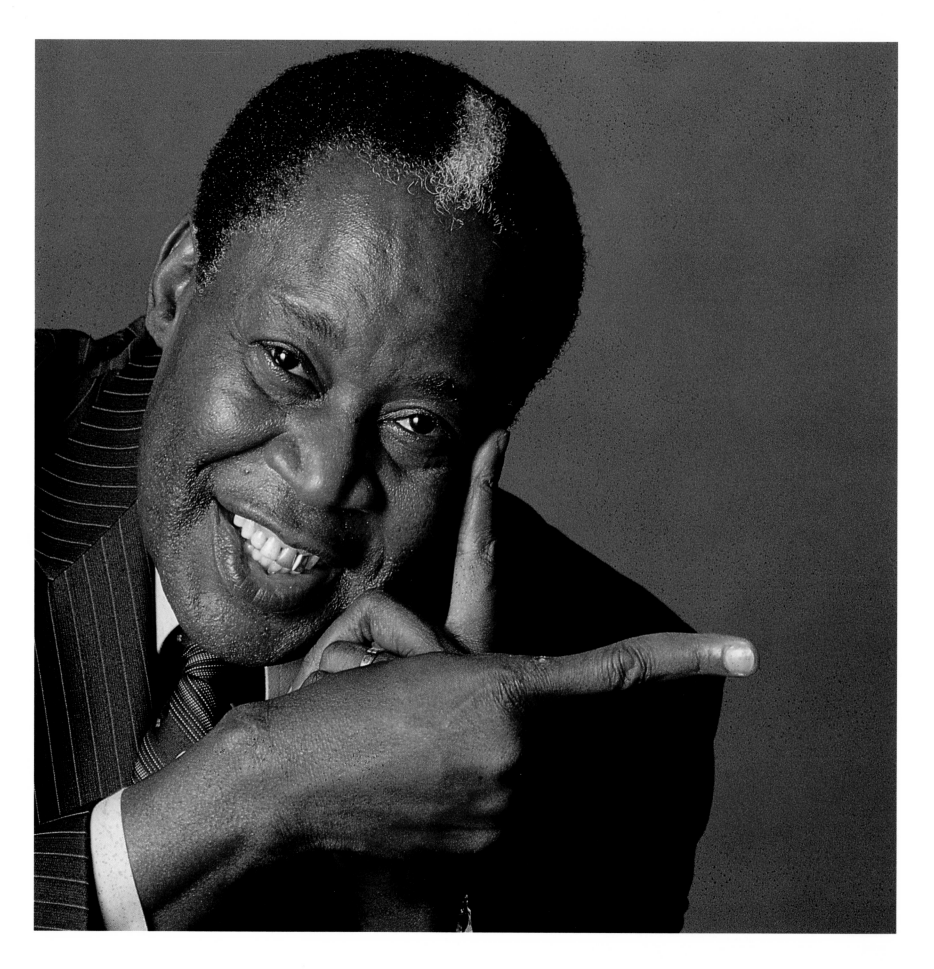

Memphis Slim, 1979

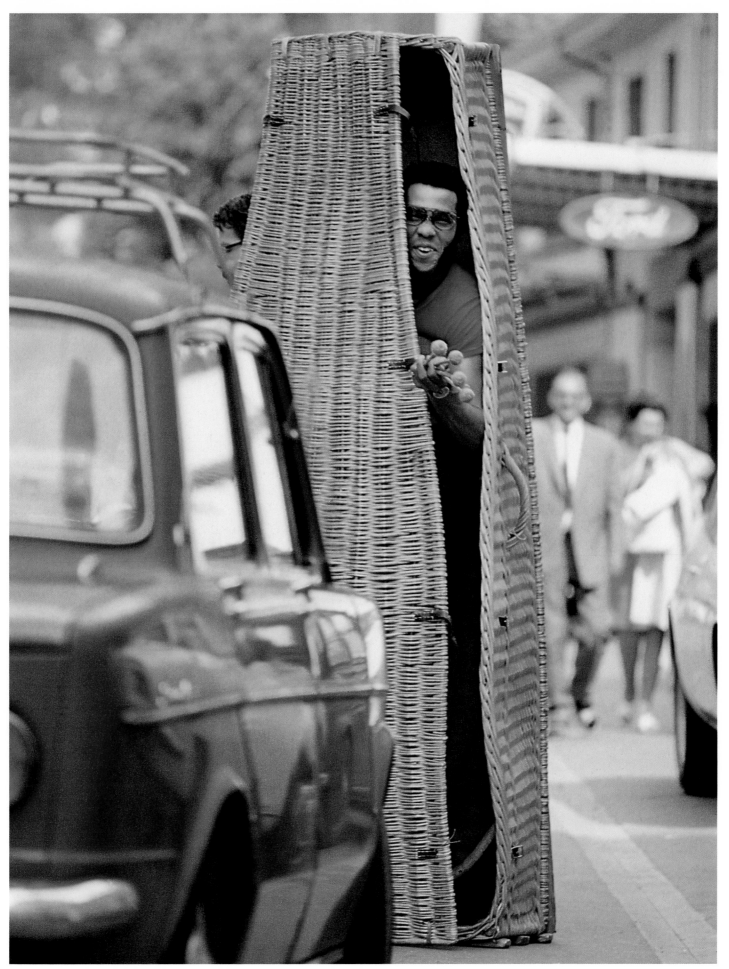

Roy Ayers, 1971

Billy Cobham, 1977

"Big" Joe Turner, 1976

Buddy Tate, 1974

Hal Singer, Buddy Tate, 1974

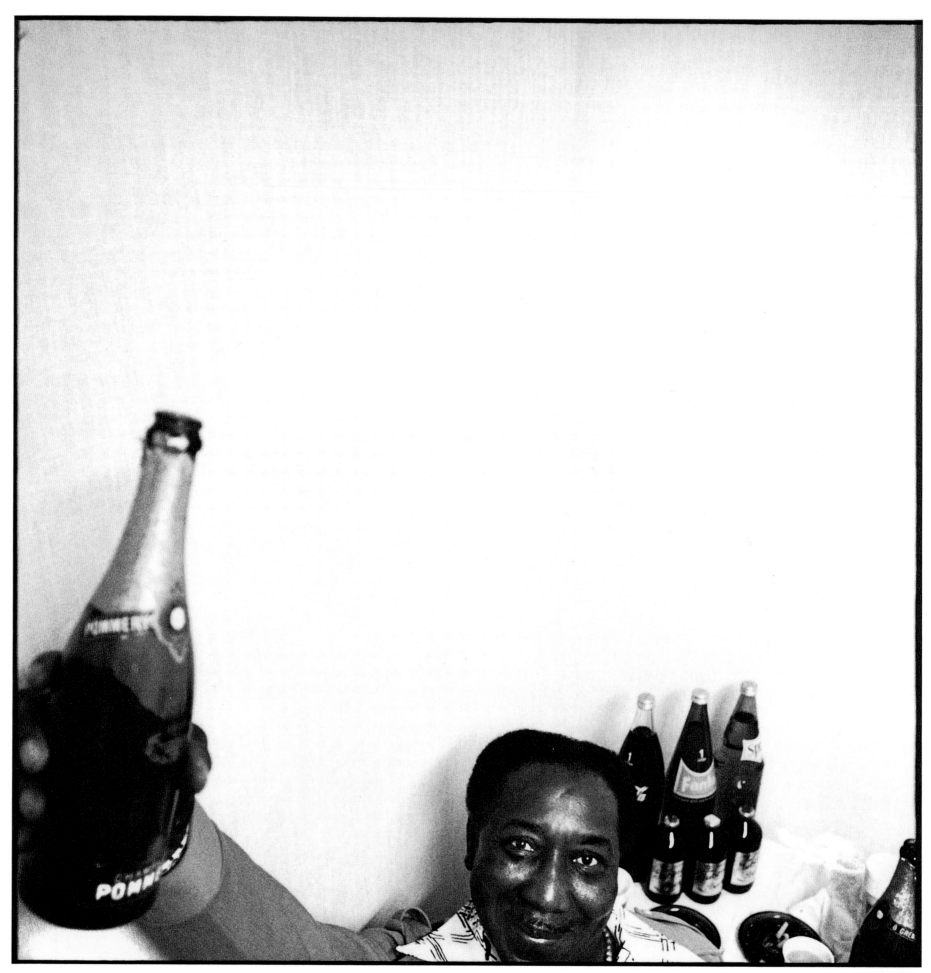

Muddy Waters, 1974

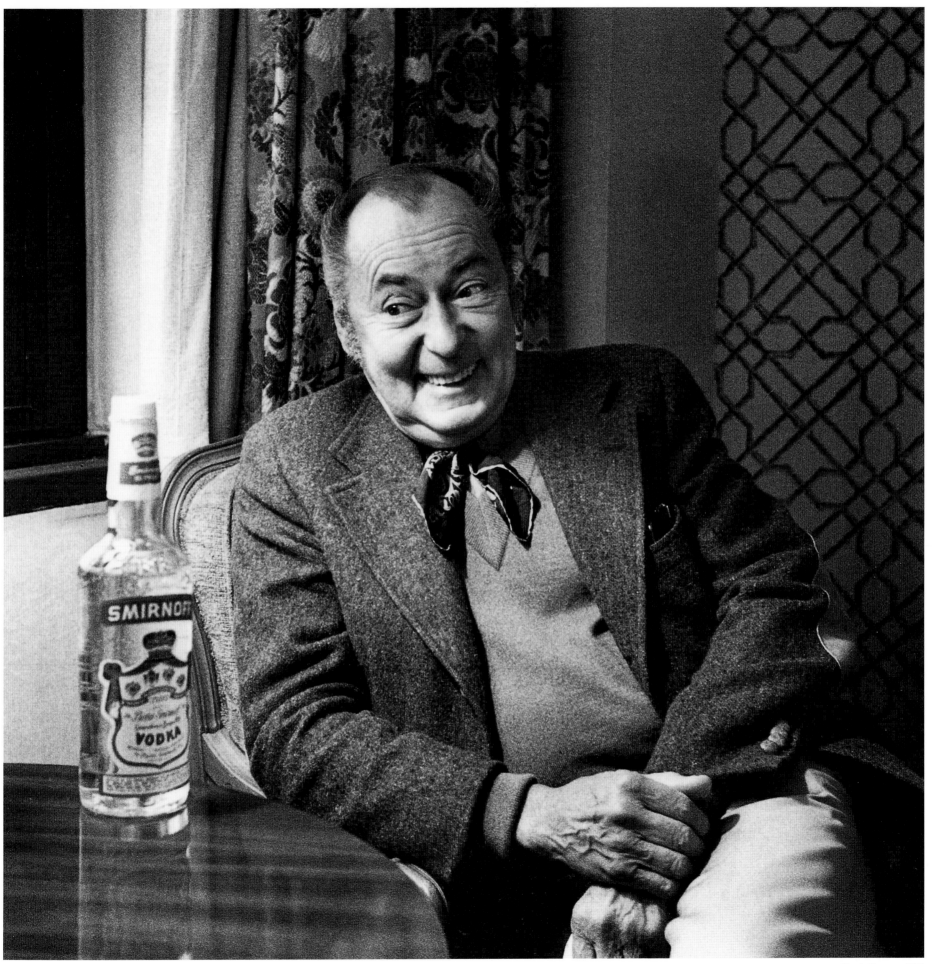

Woody Herman, 1979

Anthony Braxton, 1978

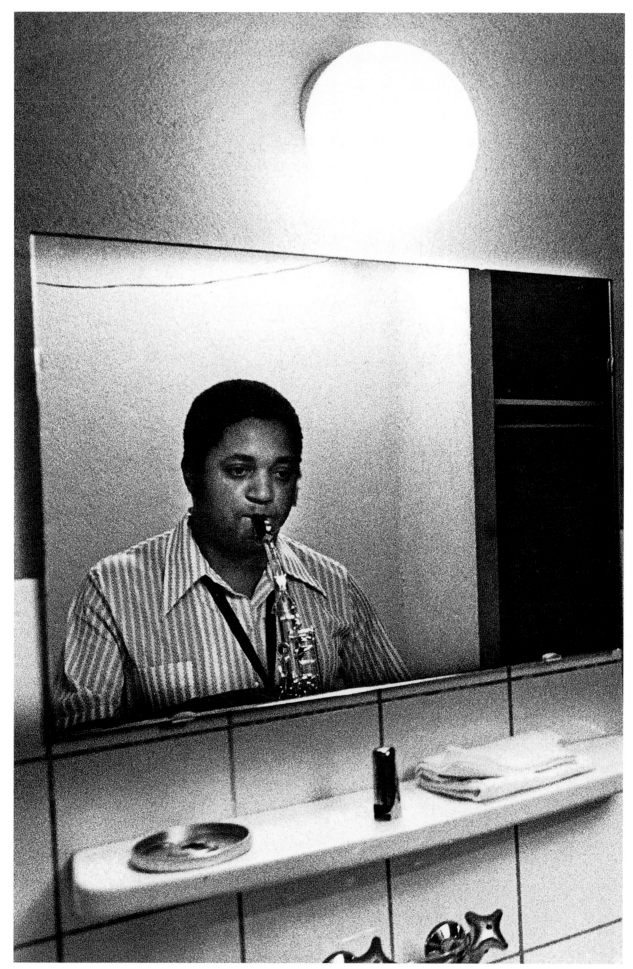

Oliver Nelson, 1971

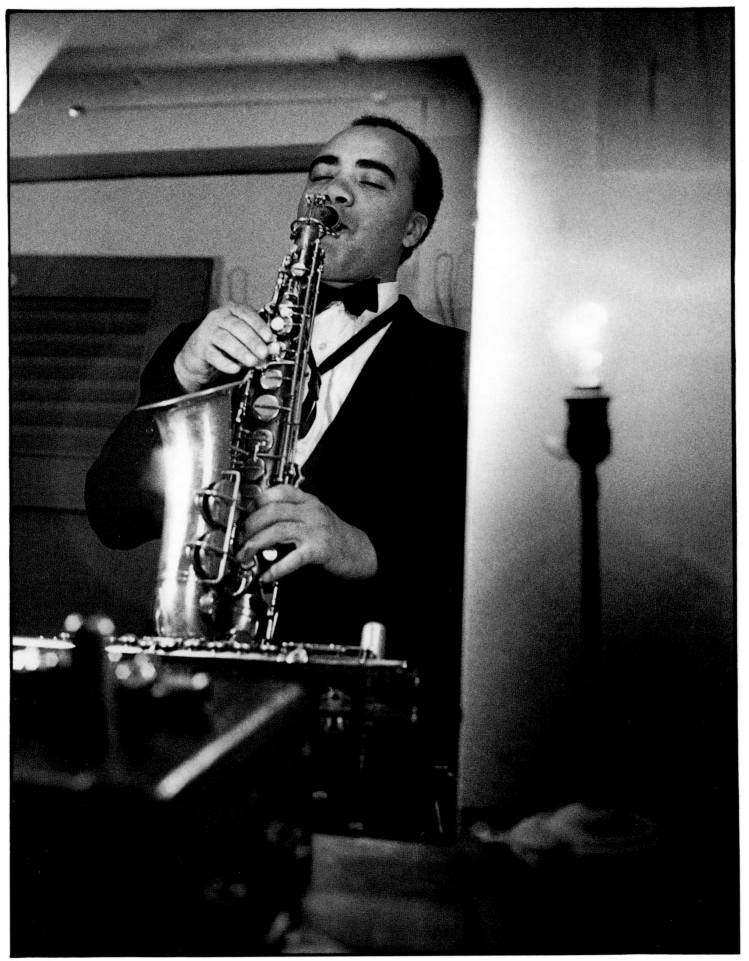

James Spaulding, 1967

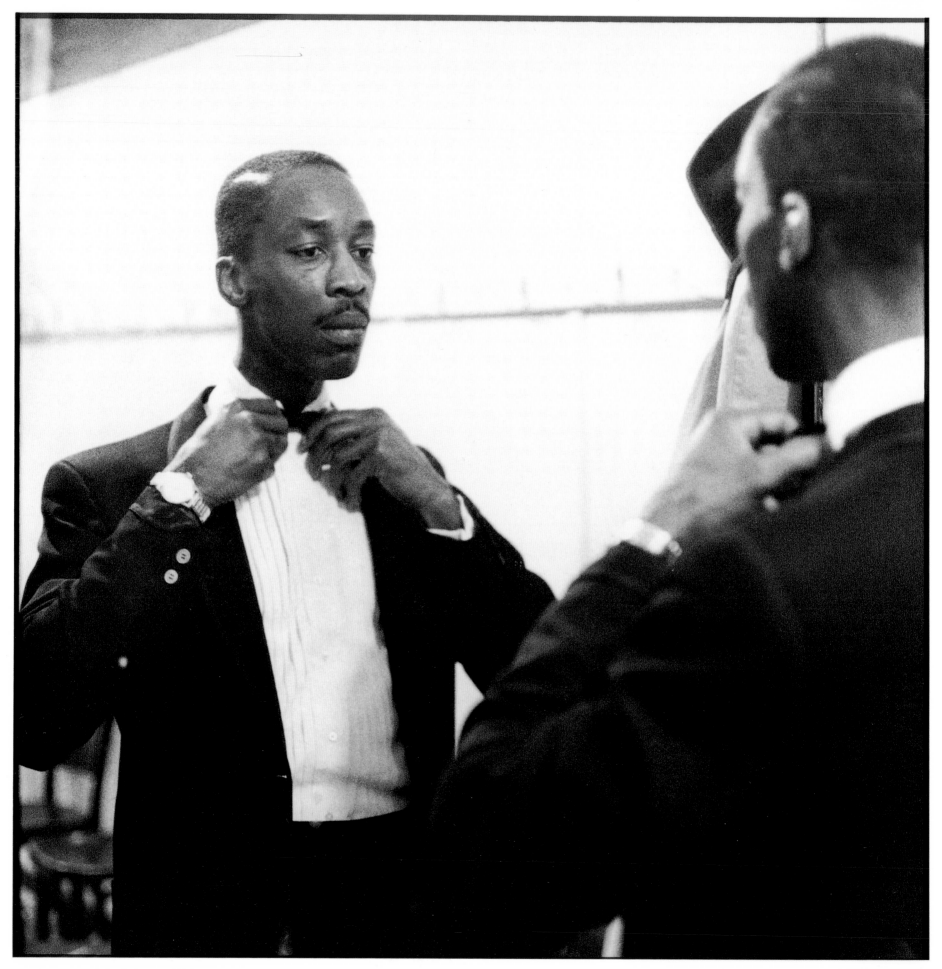

Sam Jones, 1966

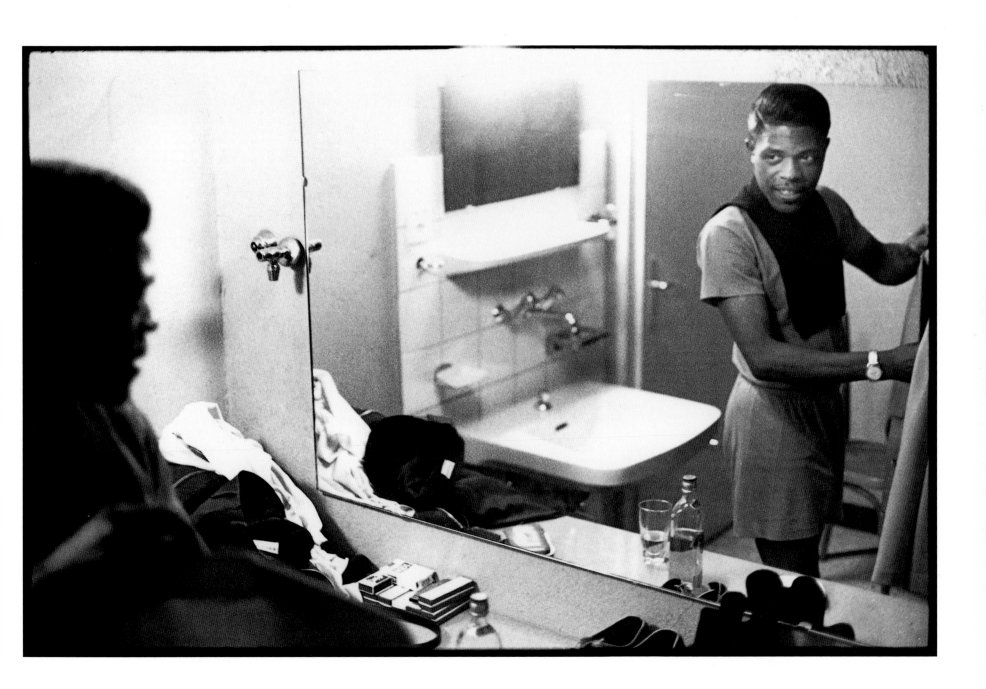

Junior Wells, 1968

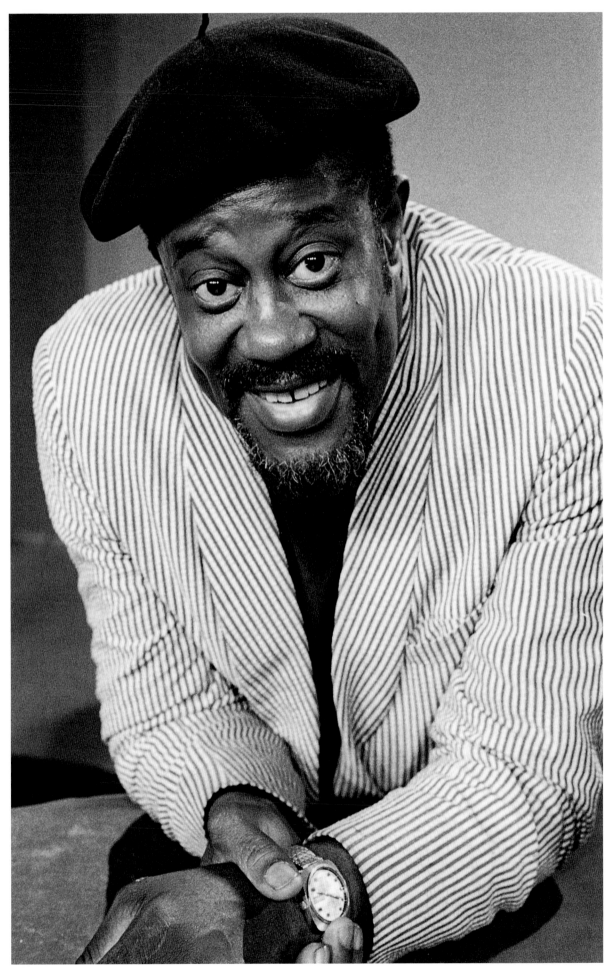

Freddie Below, 1972

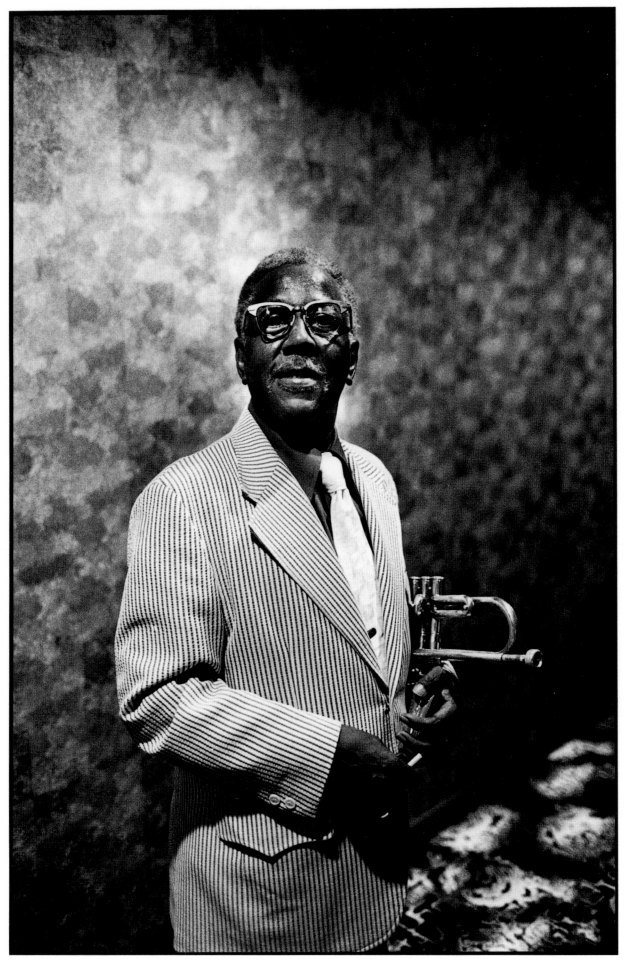

Roy Eldridge, 1975

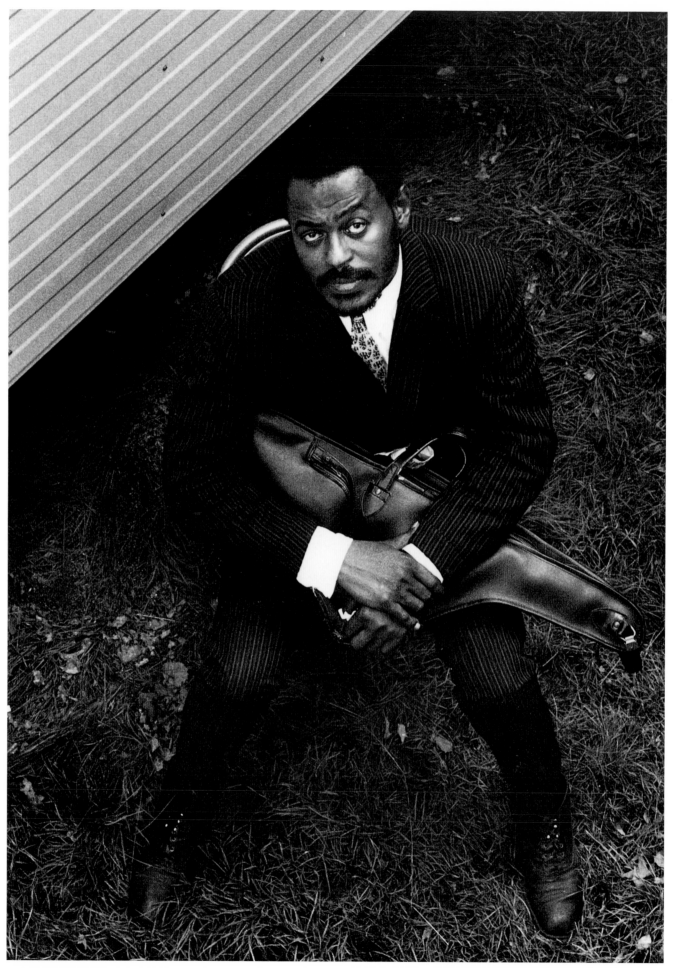

Archie Shepp, 1973

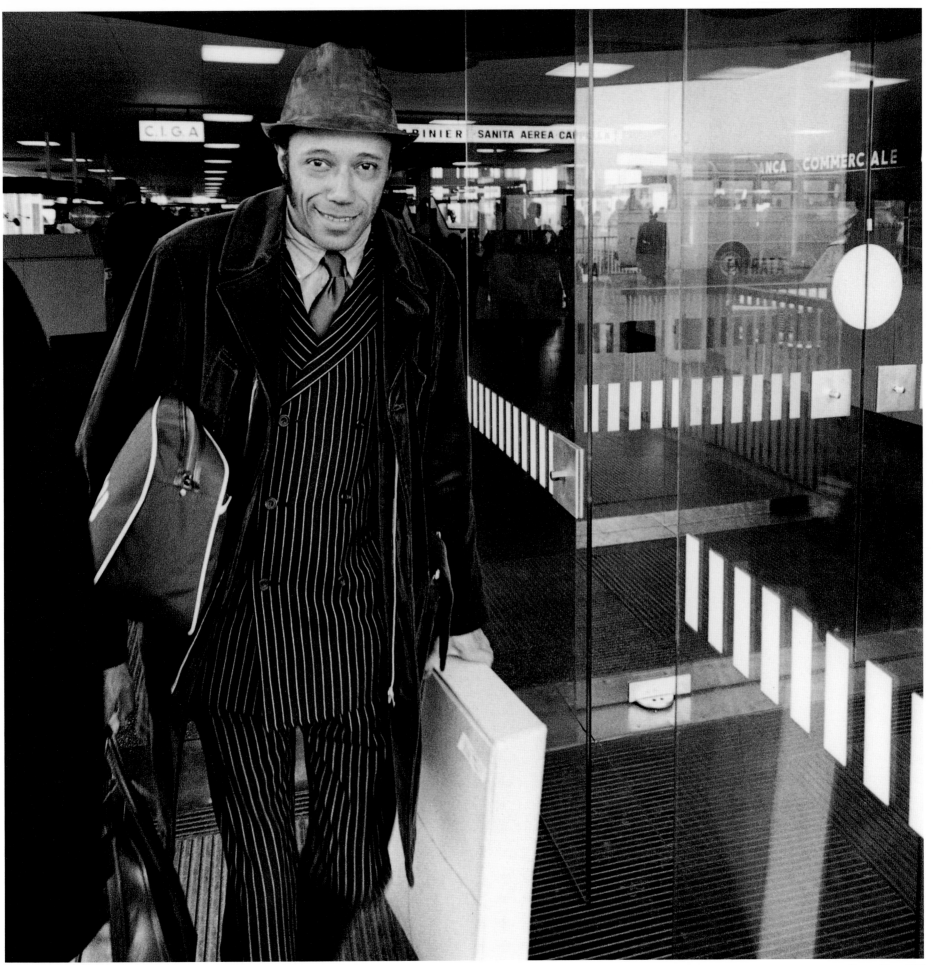

Horace Silver, 1968

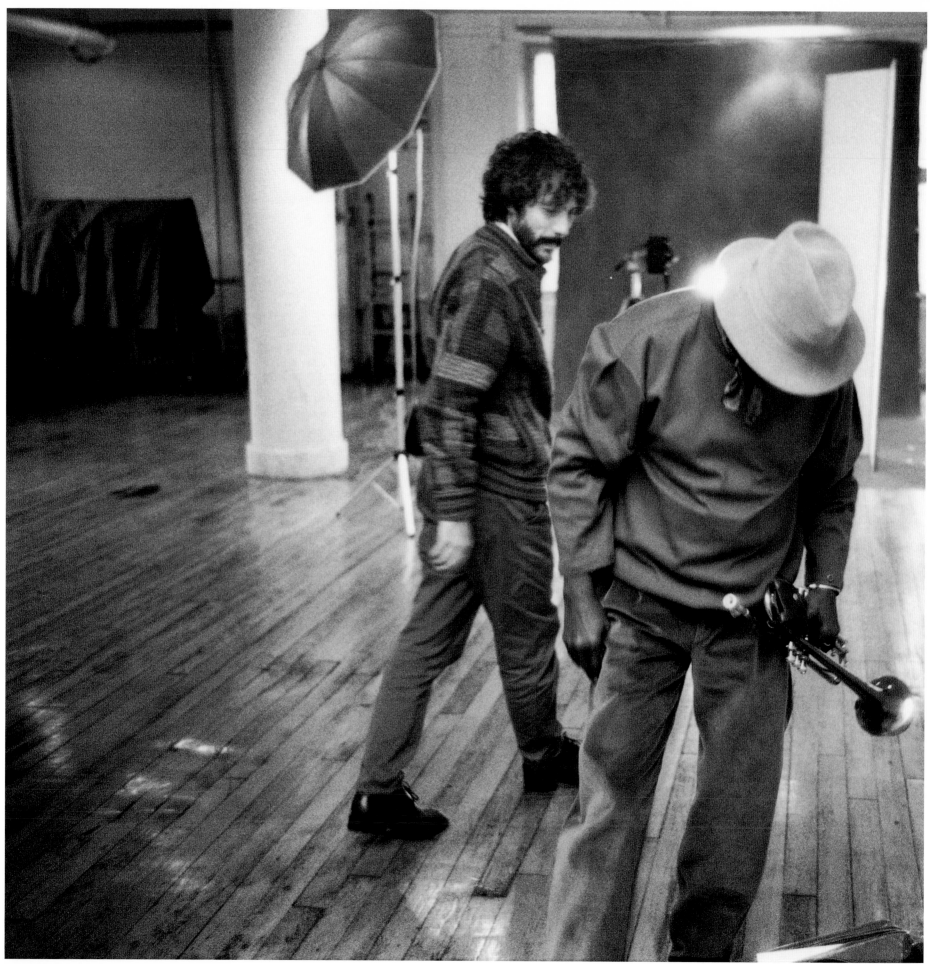

Giuseppe Pino, Miles Davis, 1982

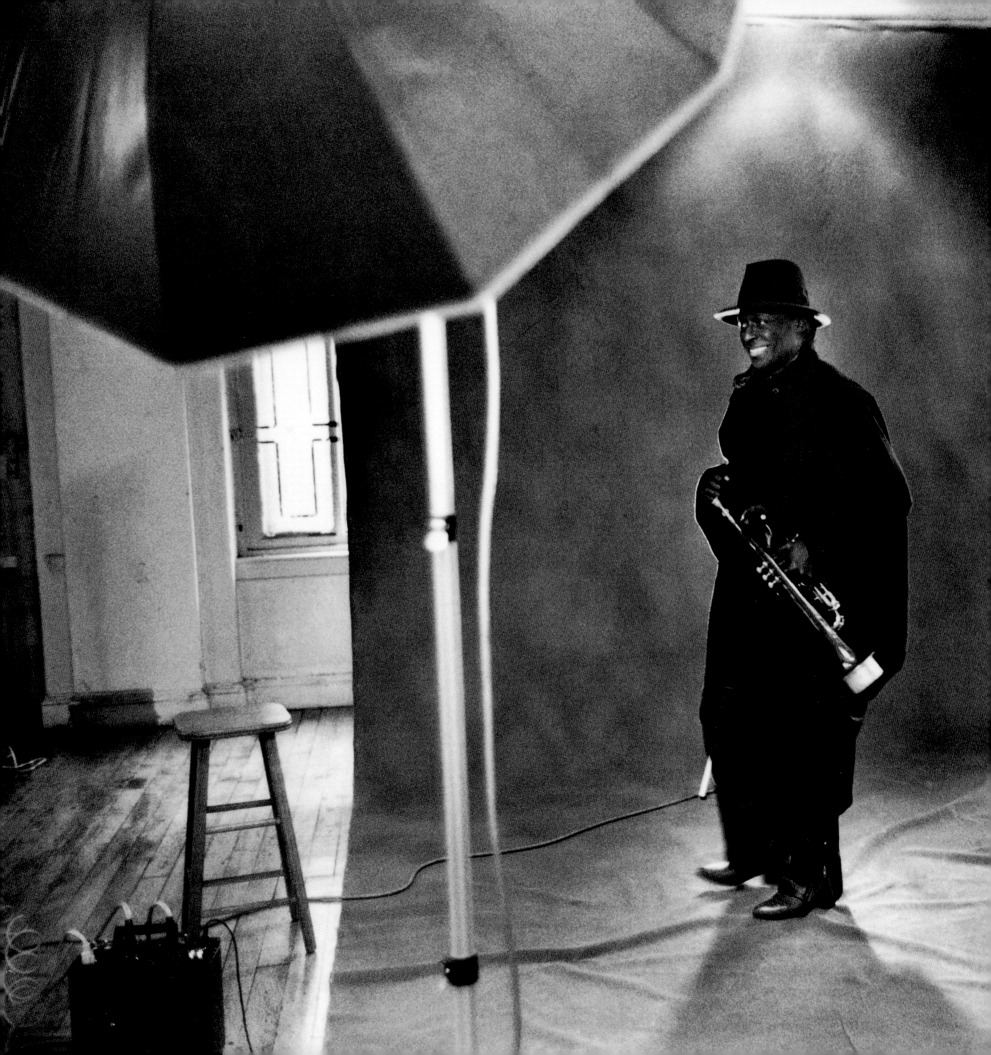

Chick Corea, 1979

Herbie Hancock, 1979

Duke Ellington, 1966

Oscar Peterson, 1977

Elvin Jones, 1975

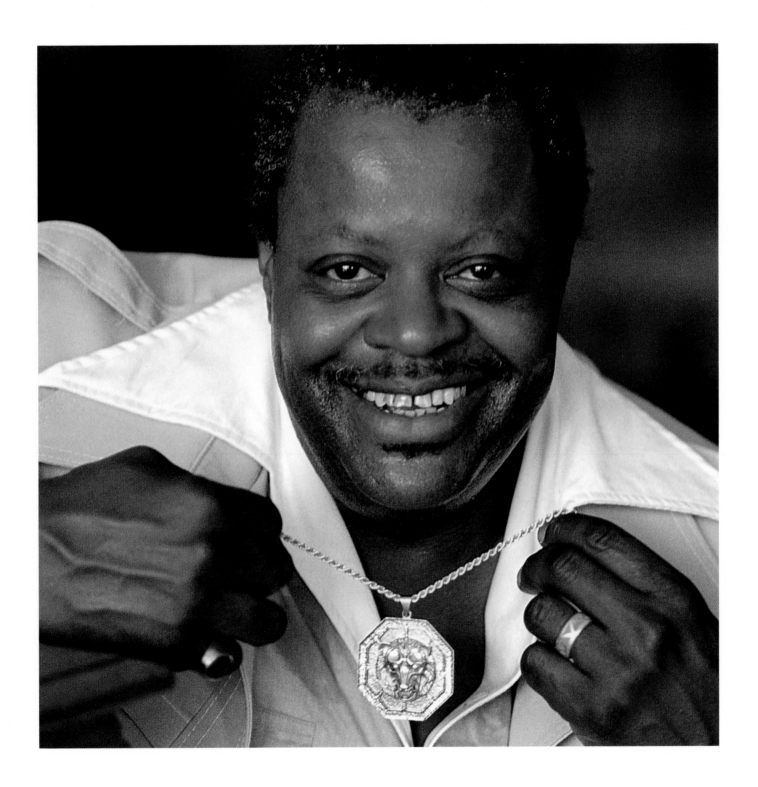

Oscar Peterson, 1975

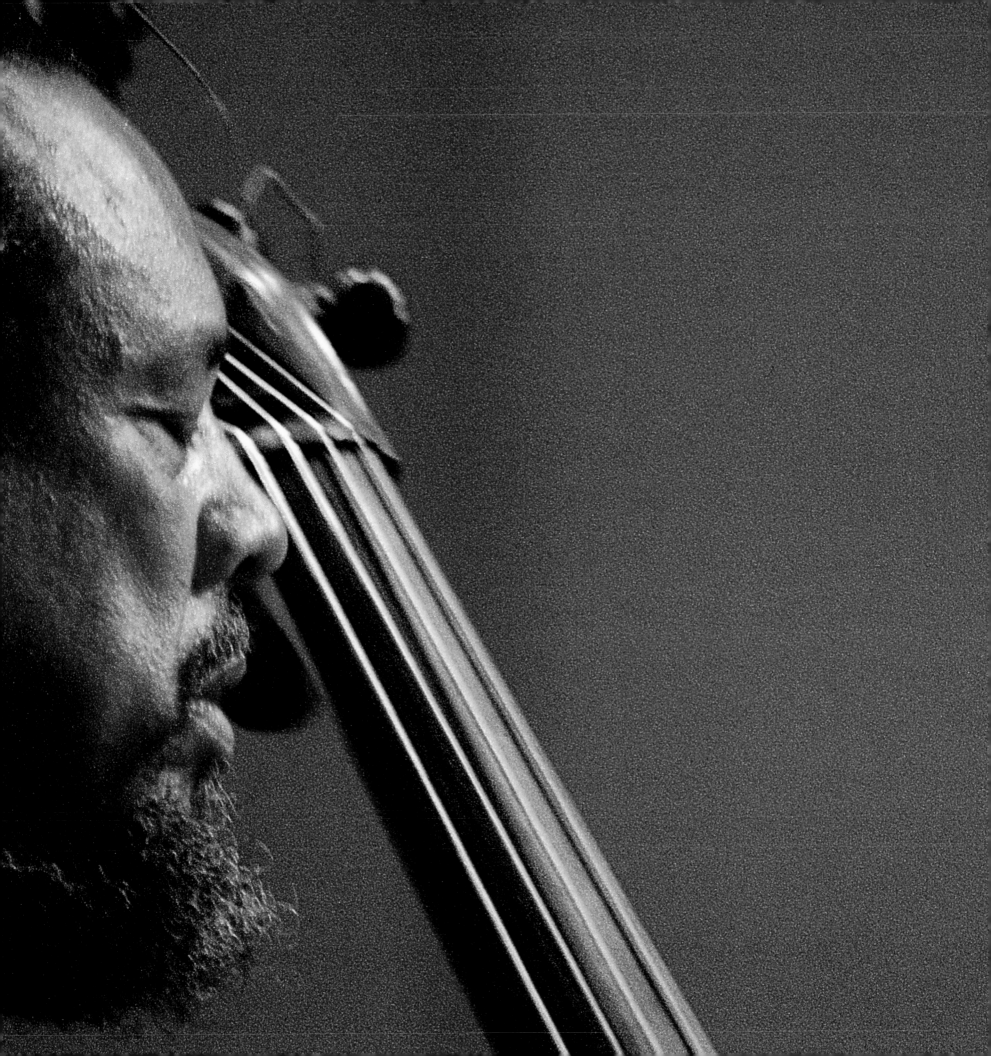

Charles Mingus, 1975

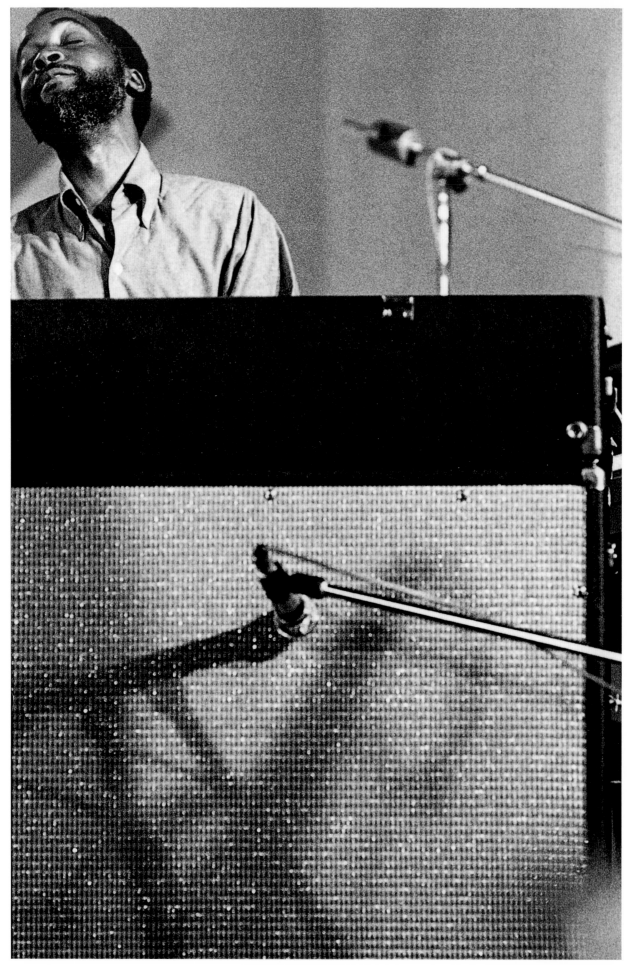

Ahmad Jamal, 1971

Chick Corea, 1969

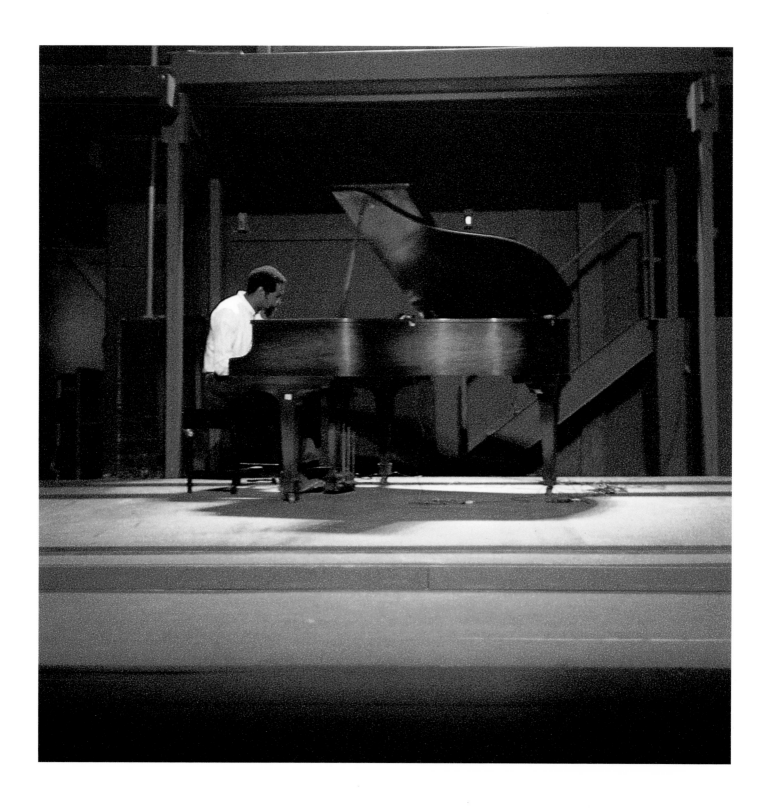

Muhal Richard Abrams, 1978

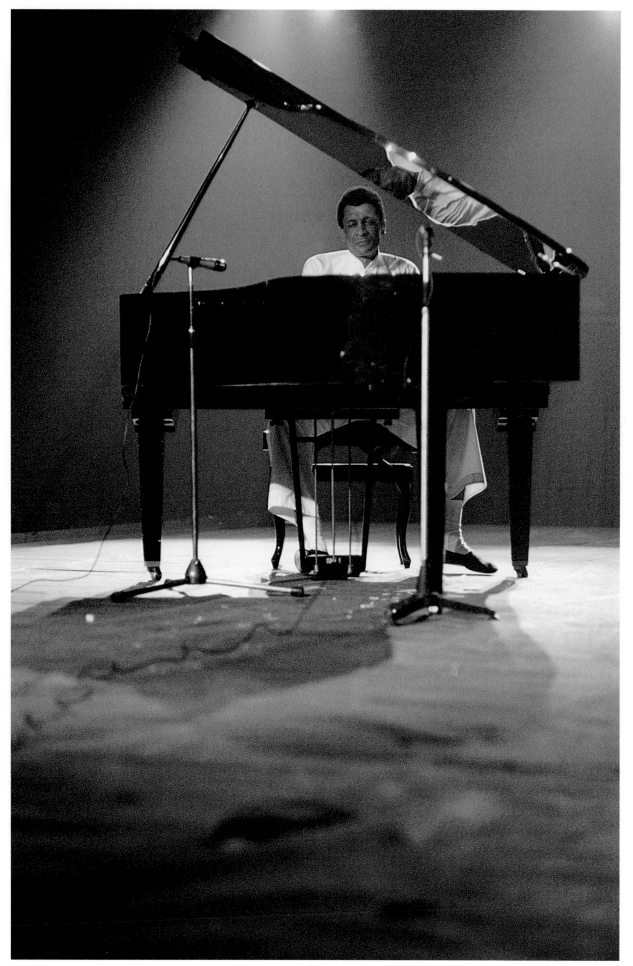

Abdullah Ibrahim, 1974

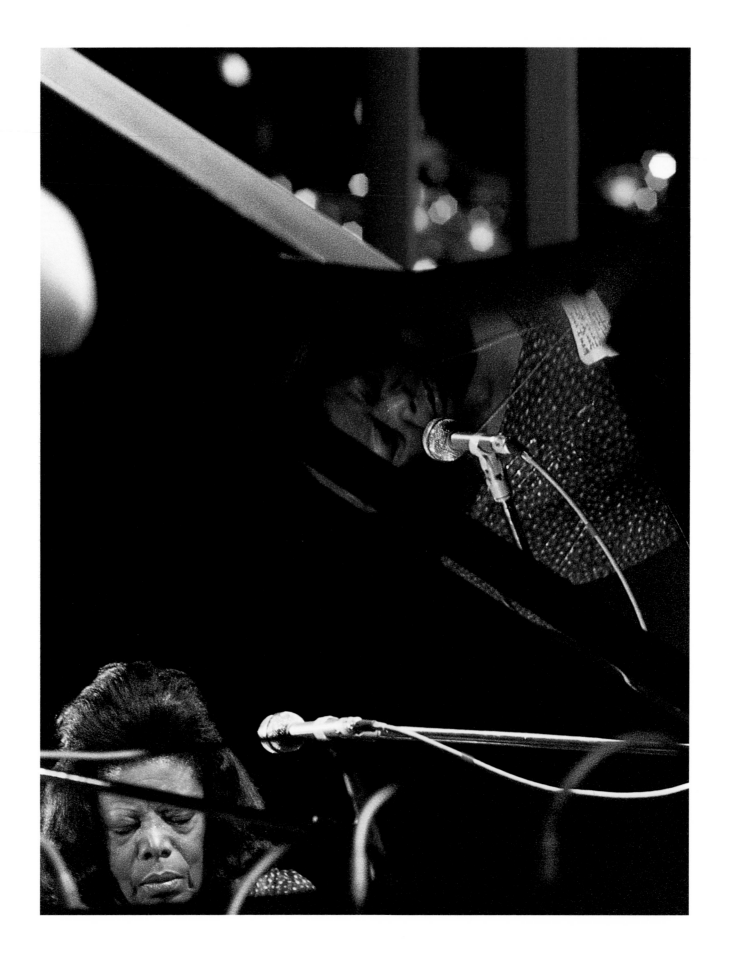

Mary Lou Williams, 1978

Chick Corea, 1978

Lennie Tristano, 1965

Ray Bryant, 1972

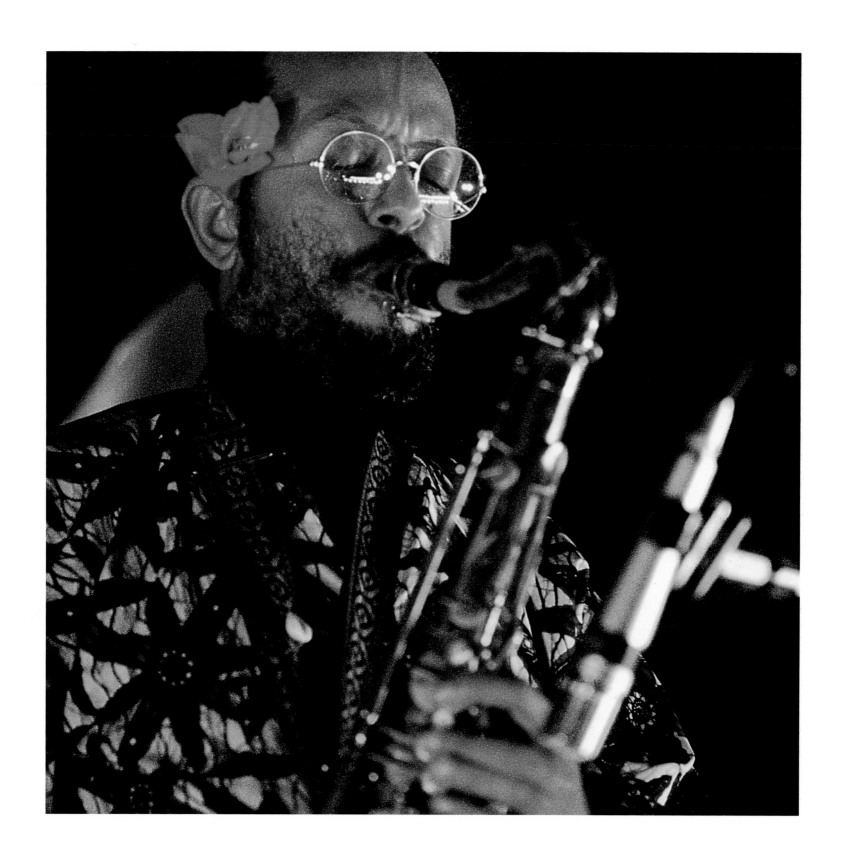

Jimmy Heath, 1977

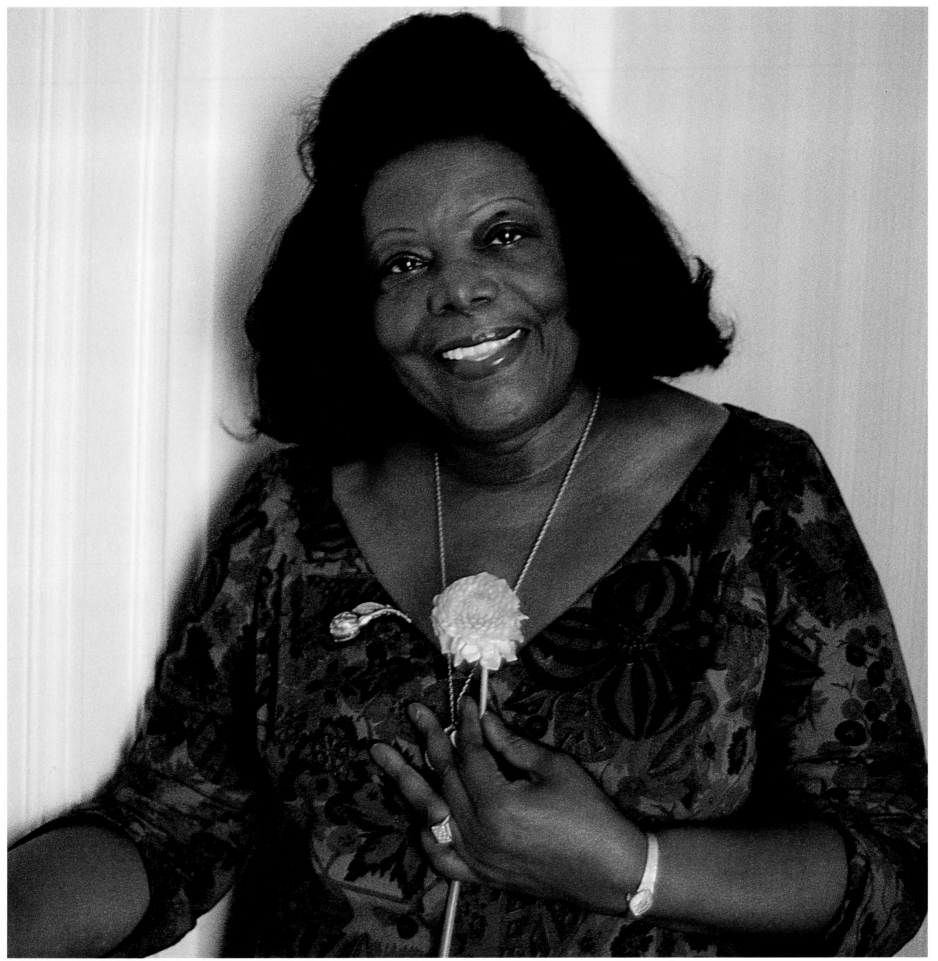

Mary Lou Williams, 1978

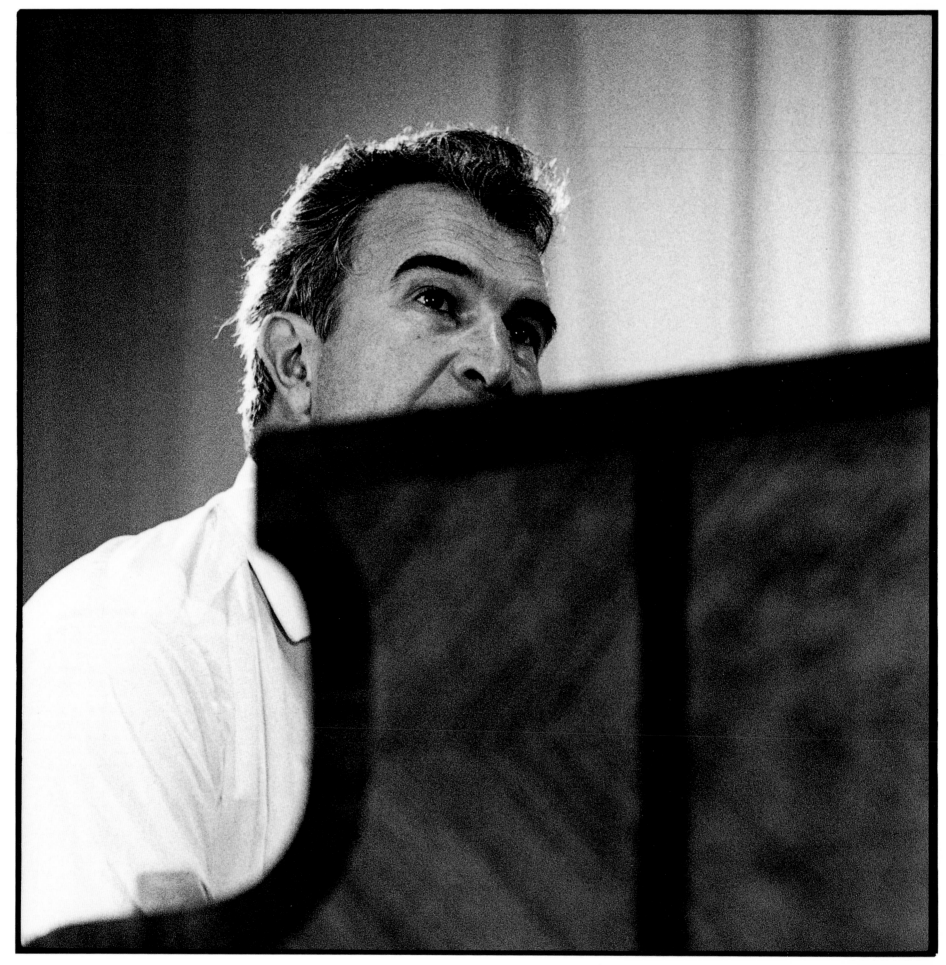

Dave Brubeck, 1967

Paul Bley, 1966

Red Mitchell, 1968

Don Moye, 1974

Lester Bowie, 1973

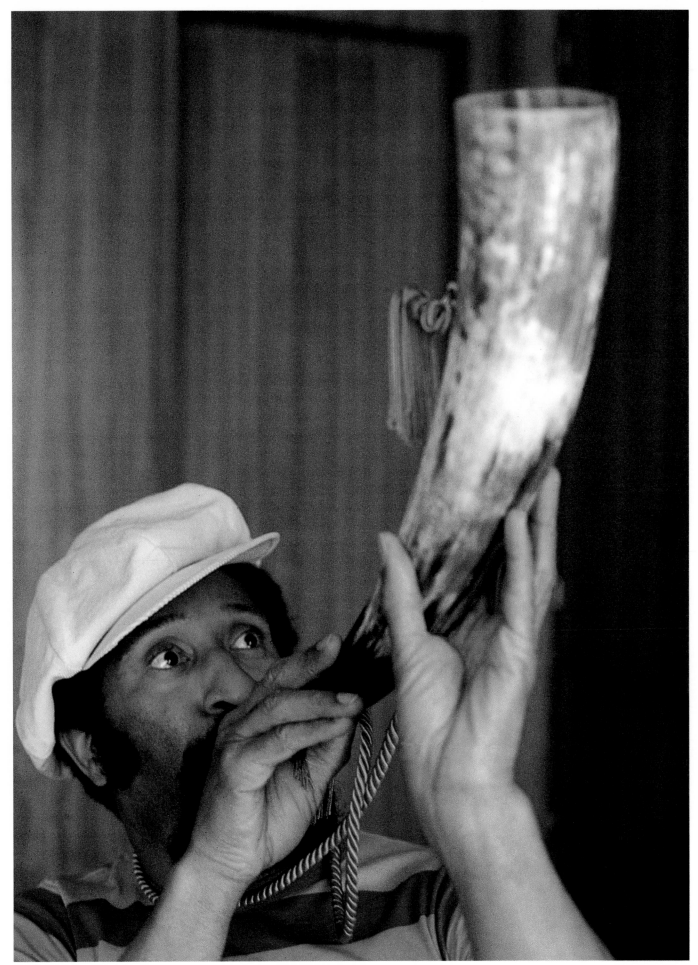

Sonny Rollins, 1974

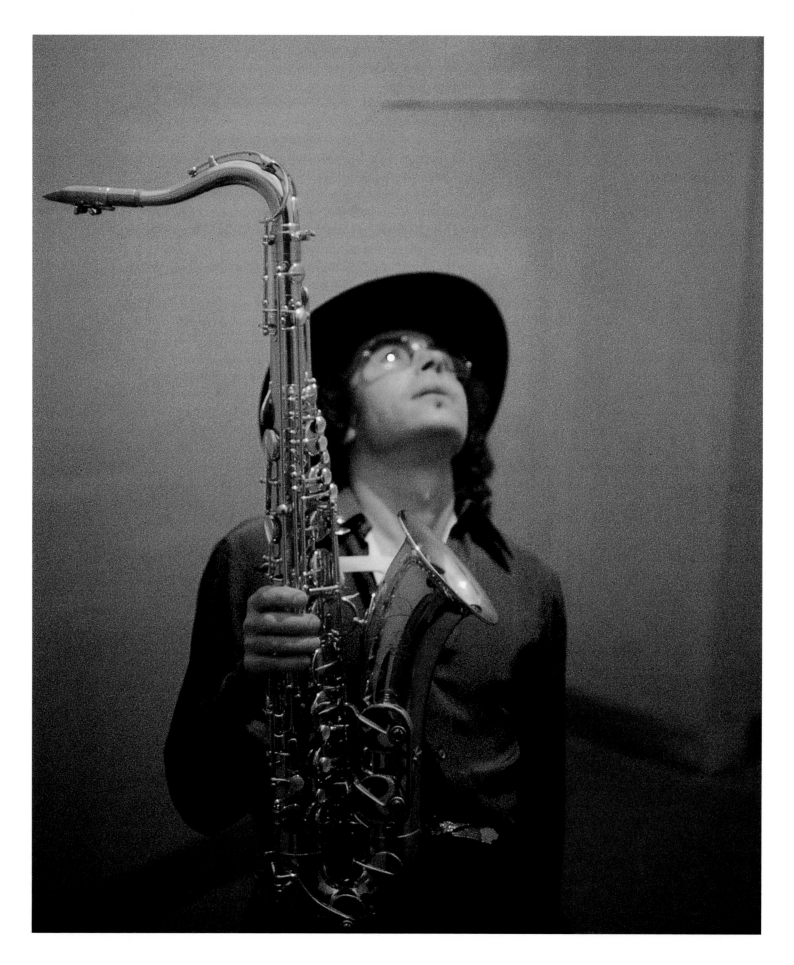

Gato Barbieri, 1974

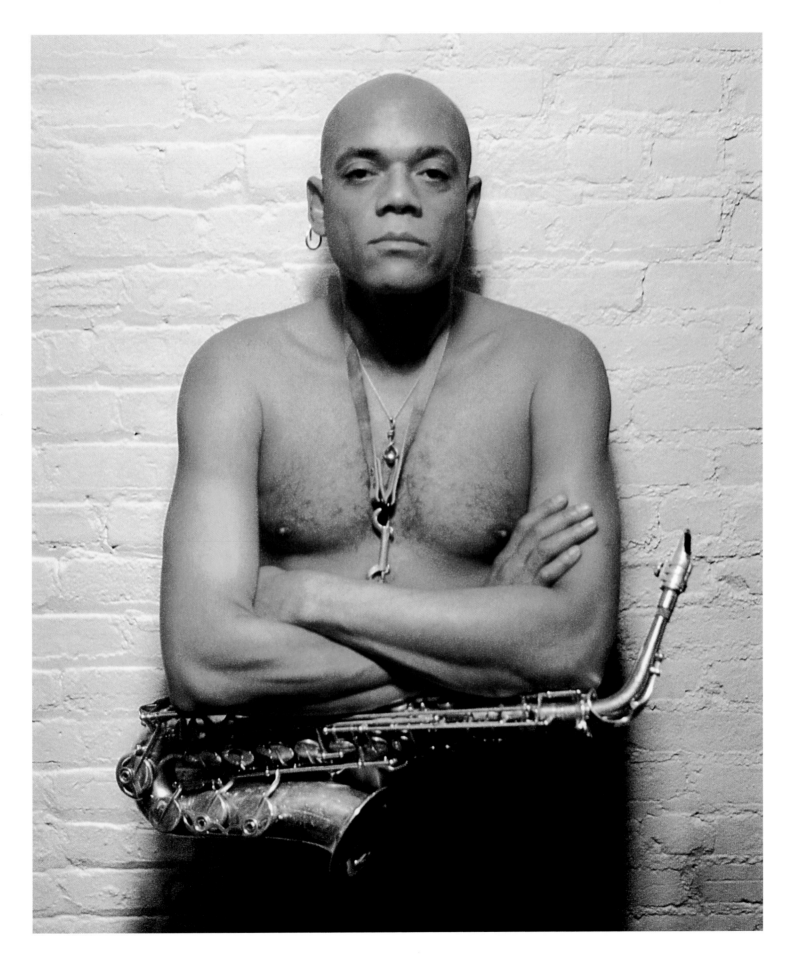

Julius Hemphill, 1977

Billy Cobham, 1978

Aldo Romano, 1997

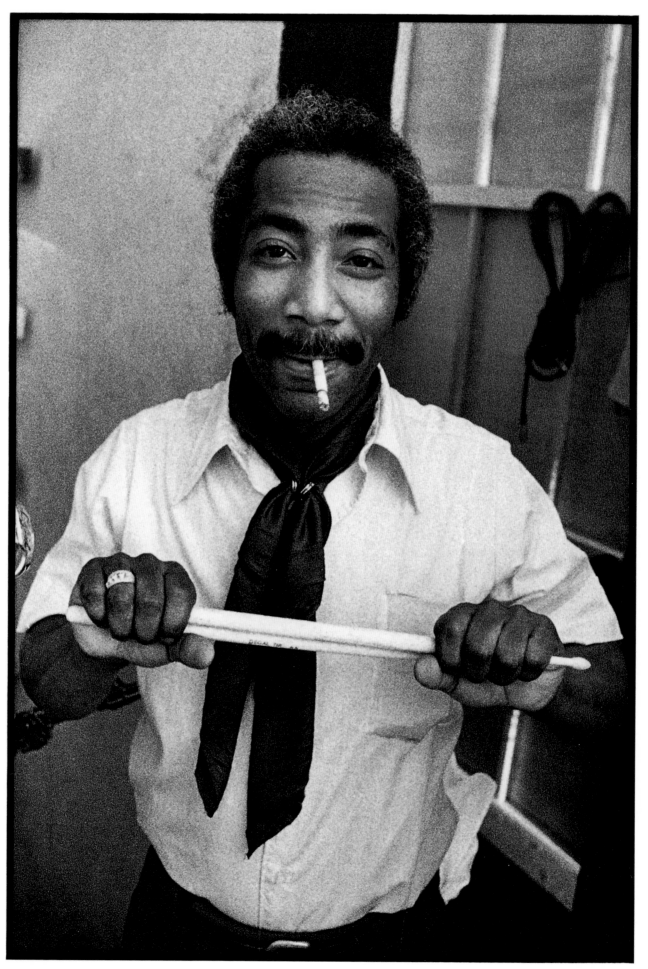

Oliver Jackson, 1970

Aldo Romano, 1997

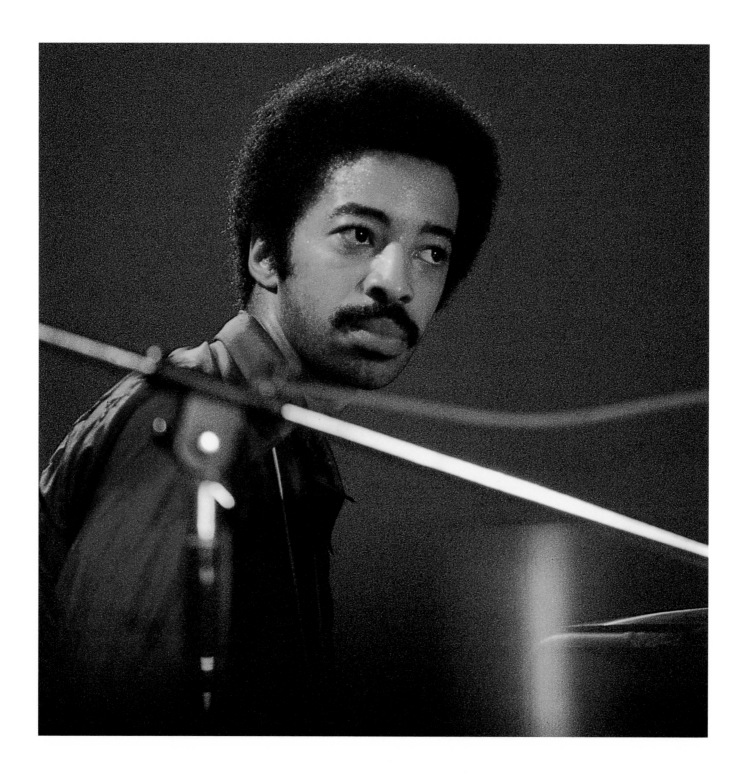

Tony Williams, 1972

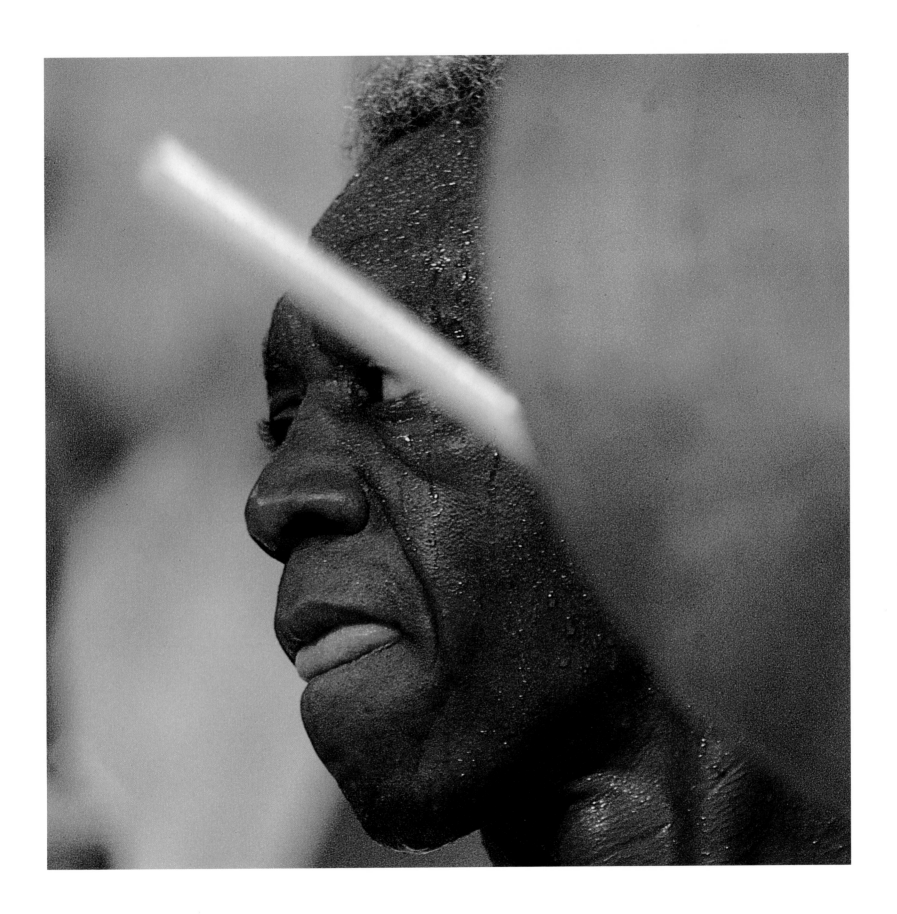

Art Blakey, 1976

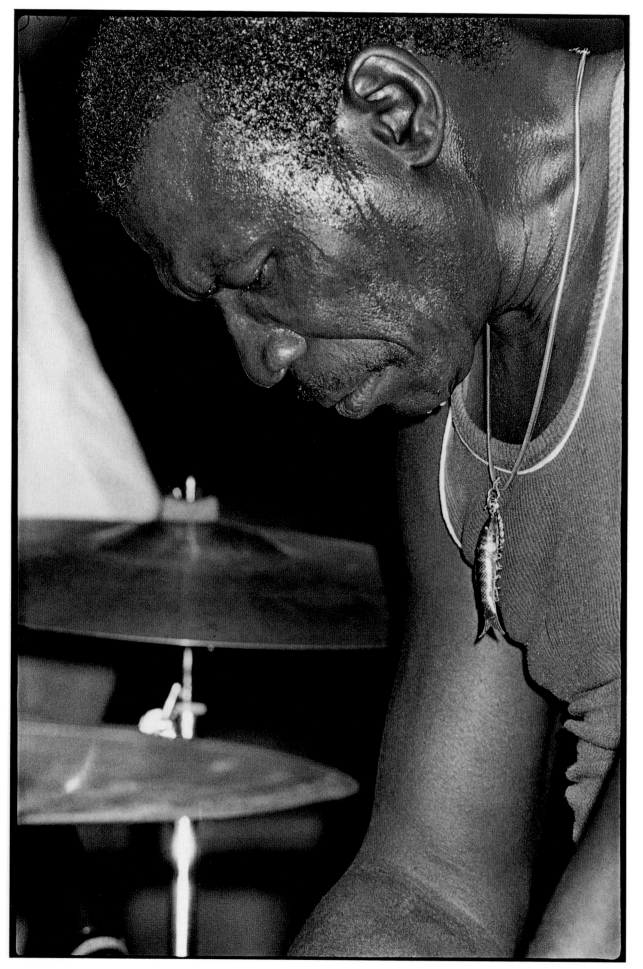

Elvin Jones, 1975

Keiko Jones, 1975

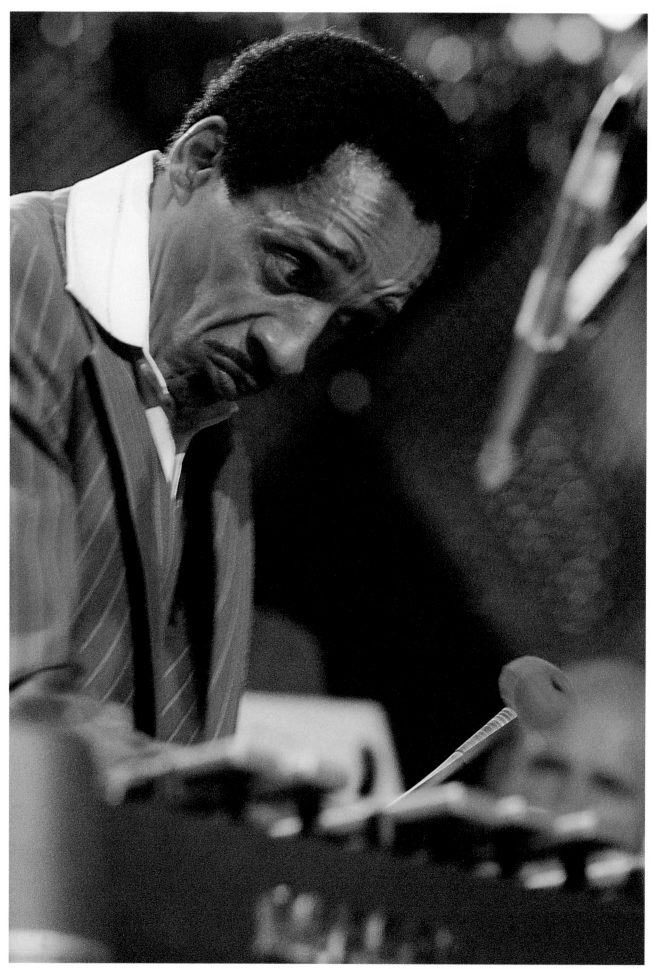

Milton Jackson, 1975

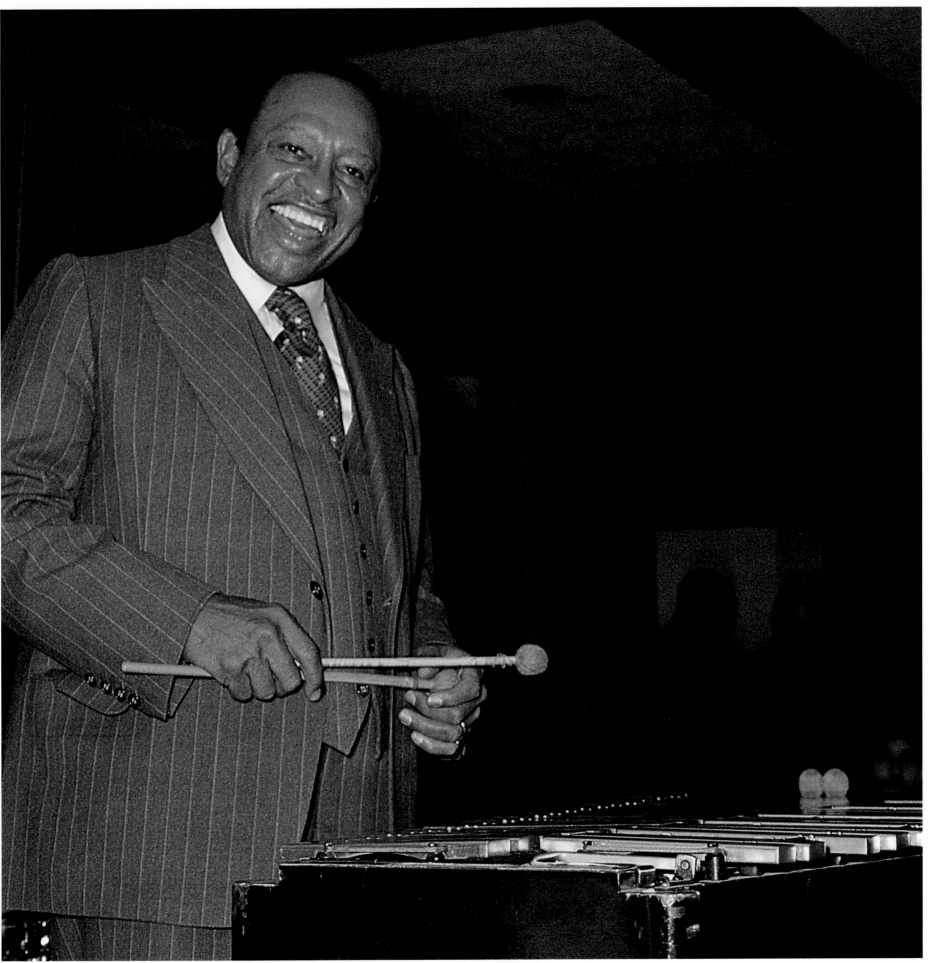

Lionel Hampton, 1979

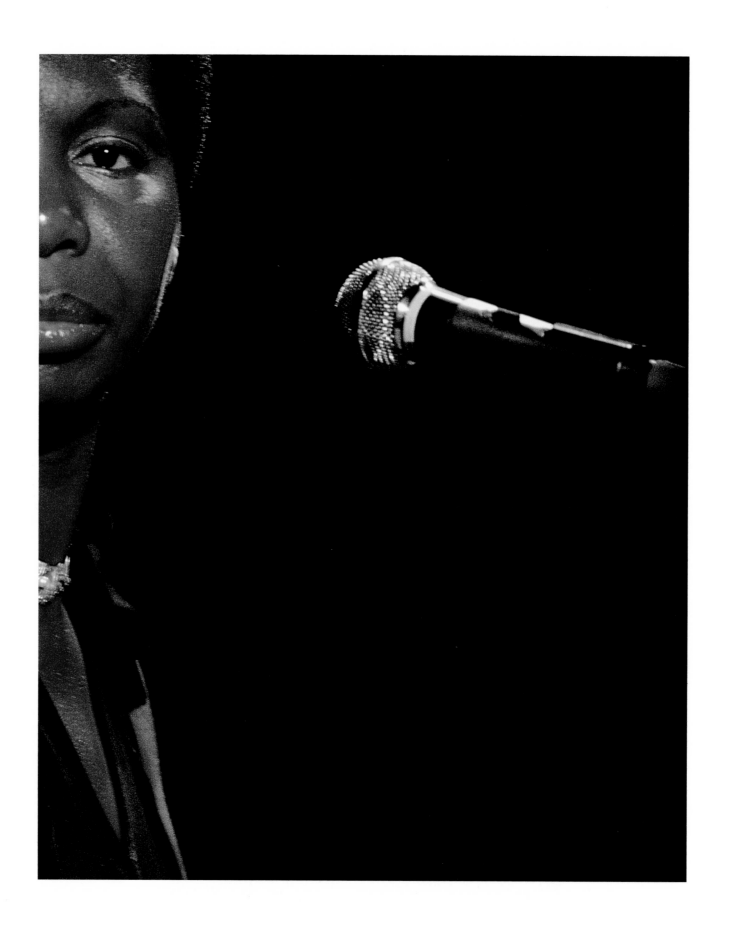

Nina Simone, 1976

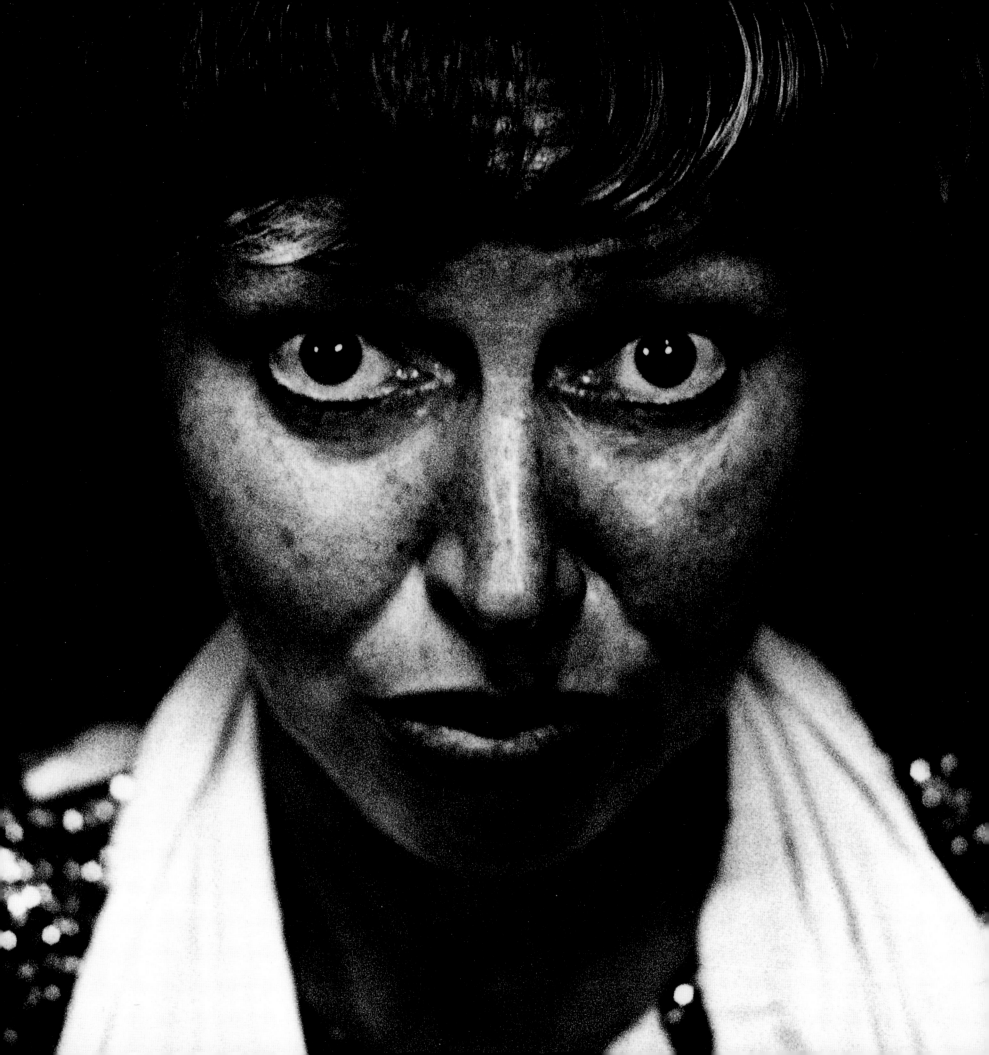

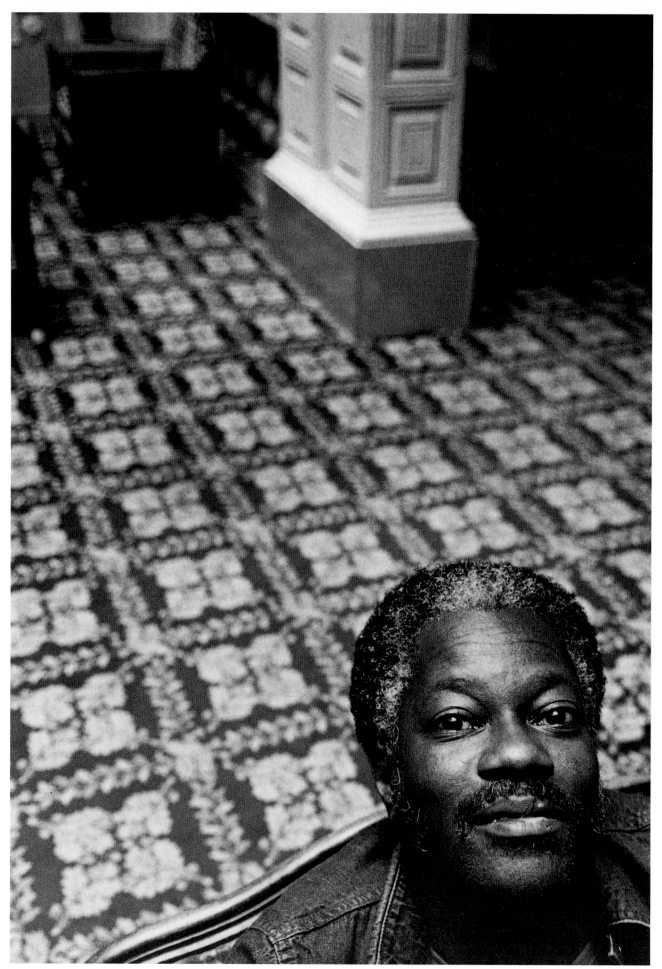

Bill Hardman, 1976

Bill Evans, 1968

Erroll Garner, 1966

Niels-Henning Örsted-Pedersen, 1975

Zoot Sims, 1975

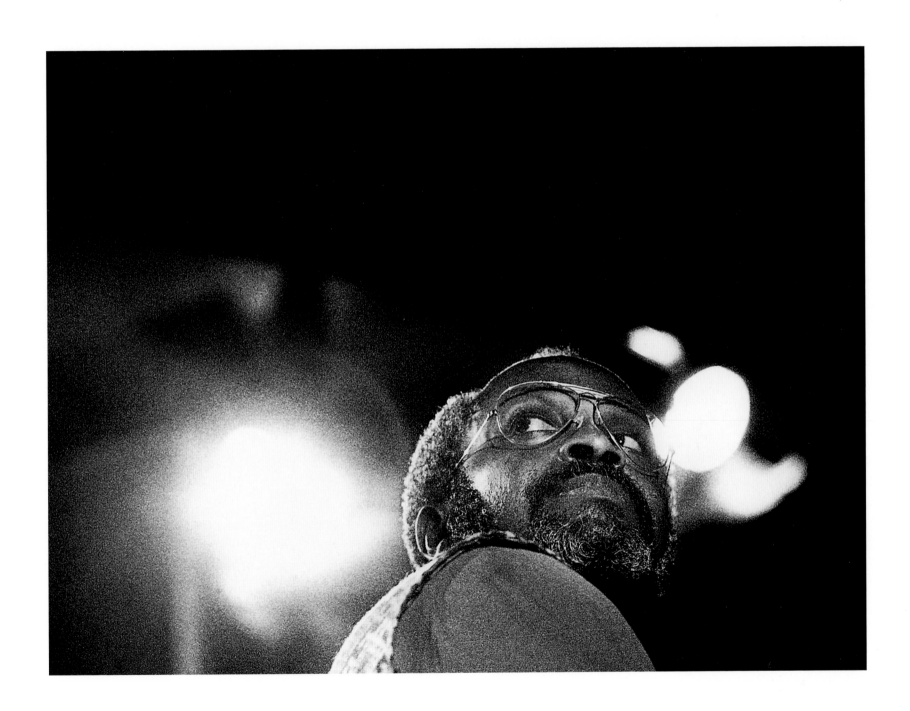

Junior Mance, 1970

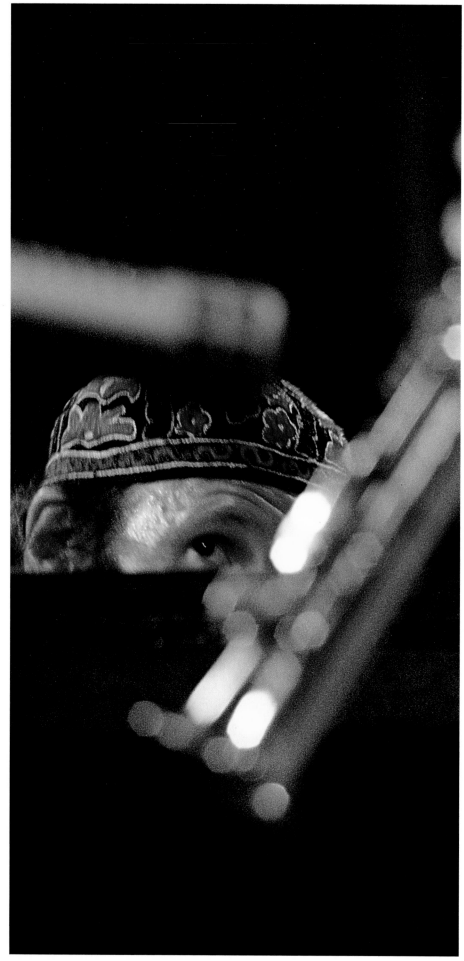

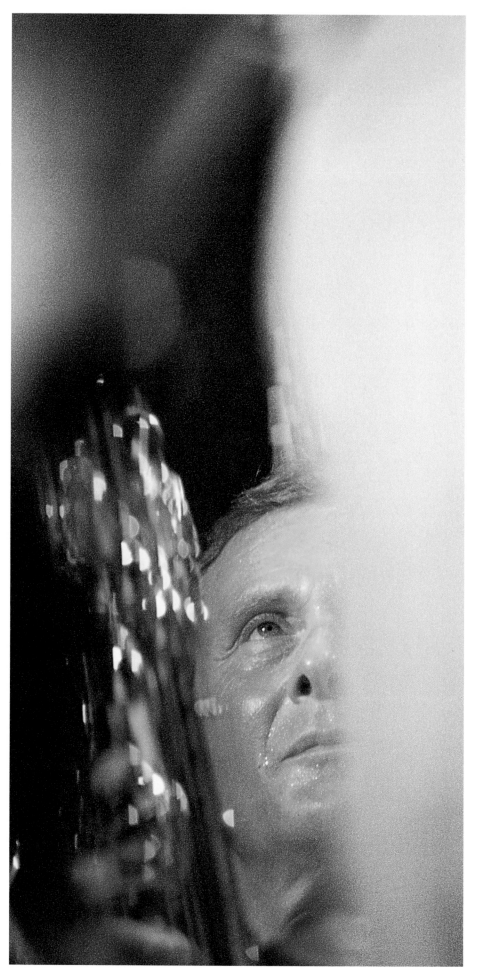

Joe Zawinul, 1976

Stan Getz, 1978

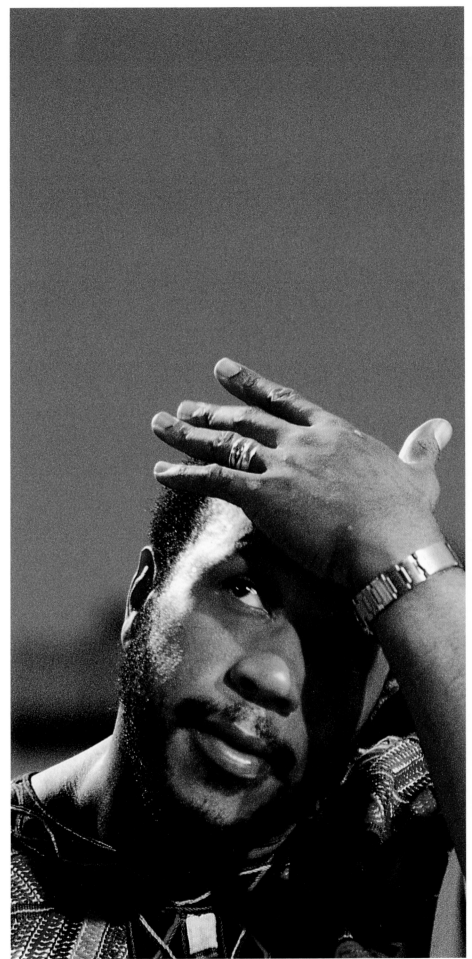

Los McCann, 1972

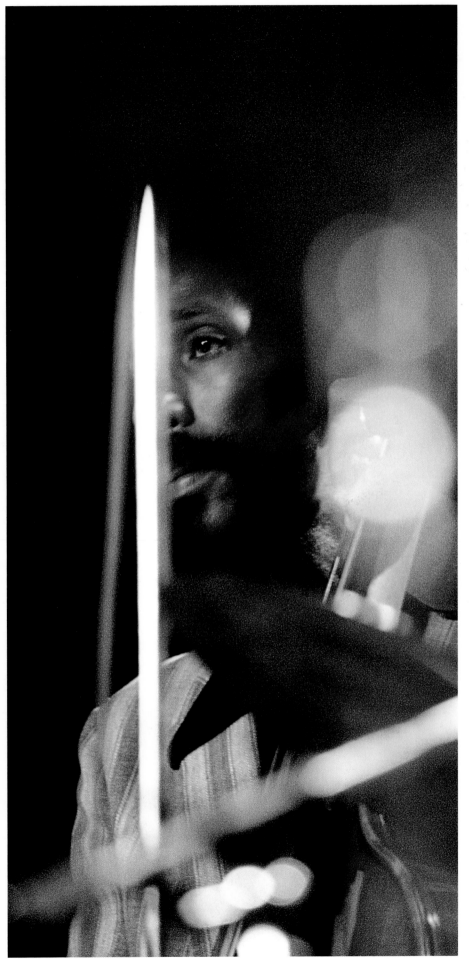

Ron Carter, 1974

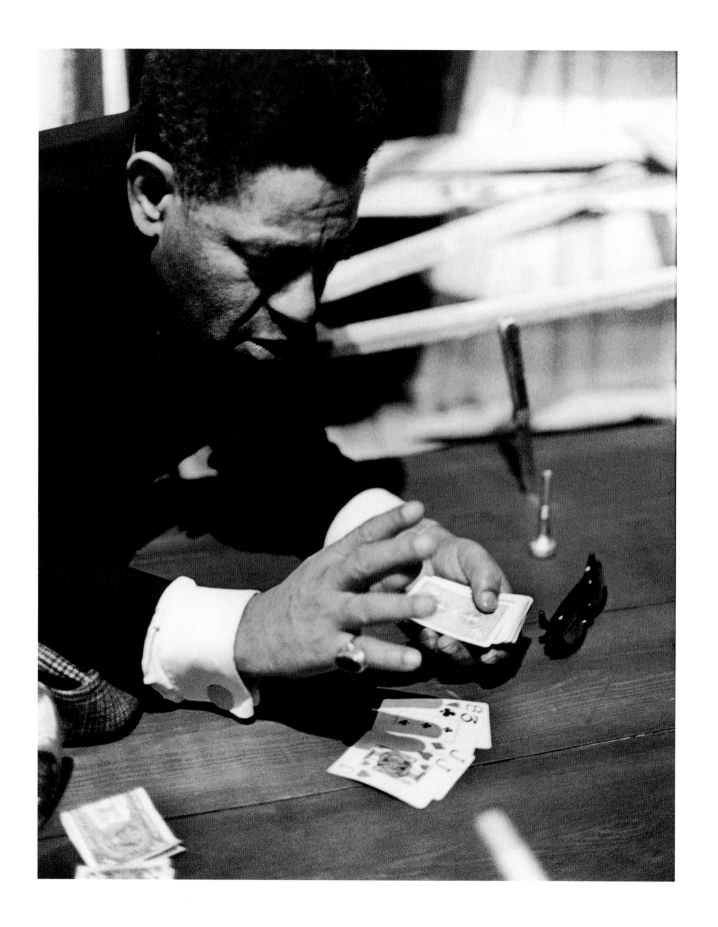

Dizzy Gillespie, 1966

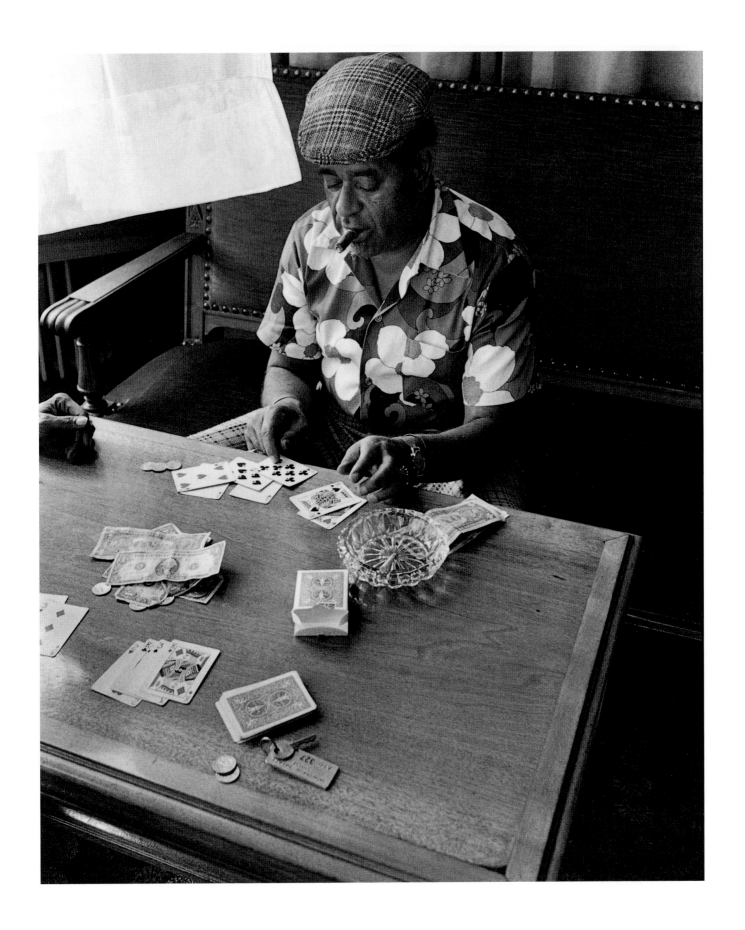

Dizzy Gillespie, 1975

Herbie Mann, 1977

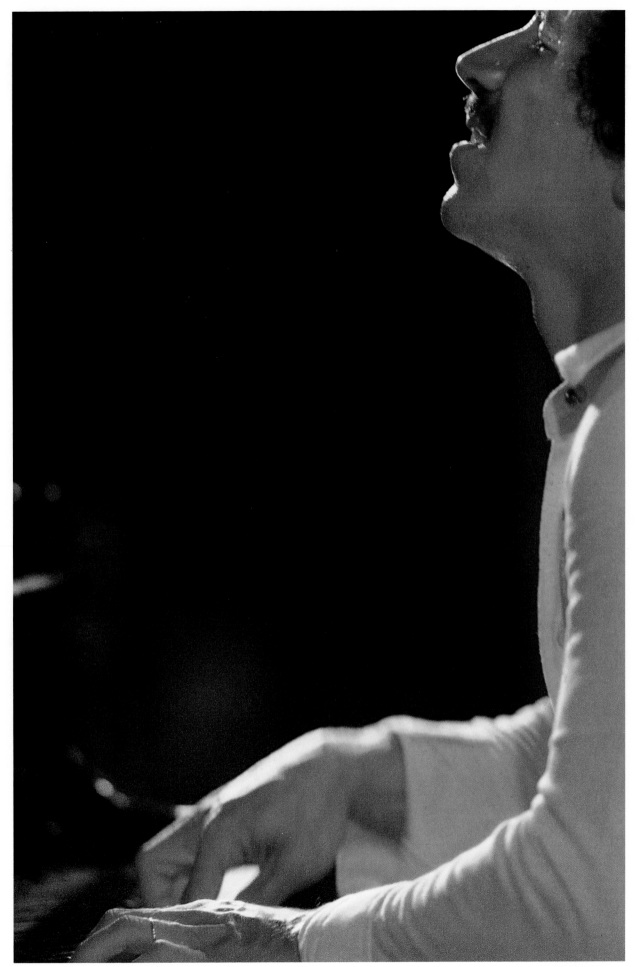

Keith Jarrett, 1974

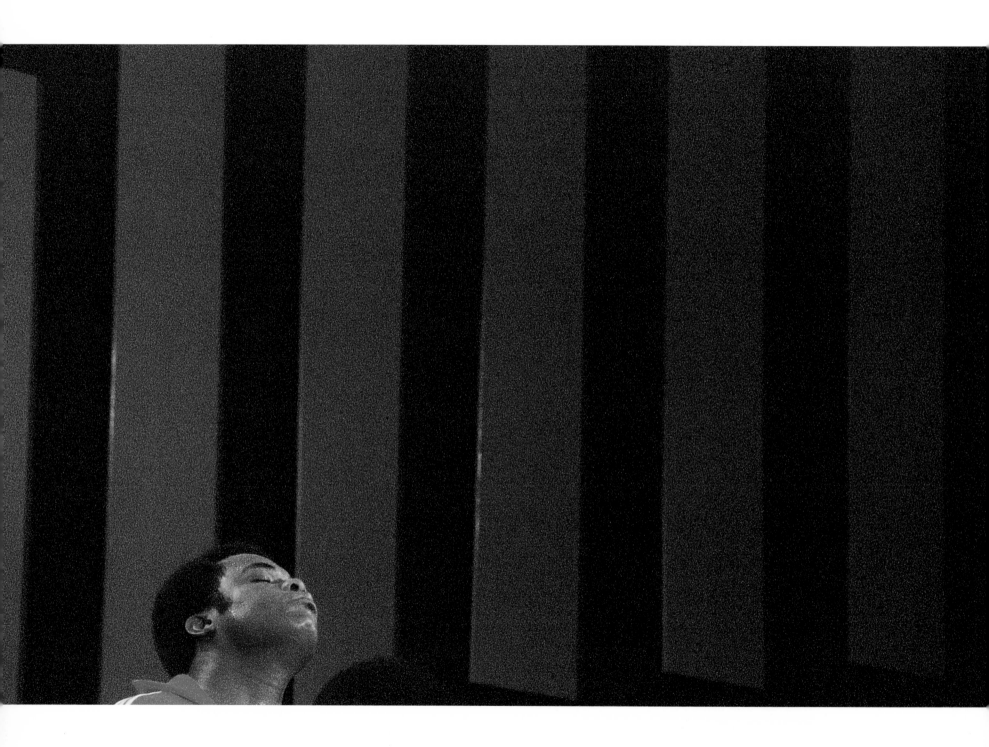

Freddie Hubbard, 1977

Dexter Gordon, 1978

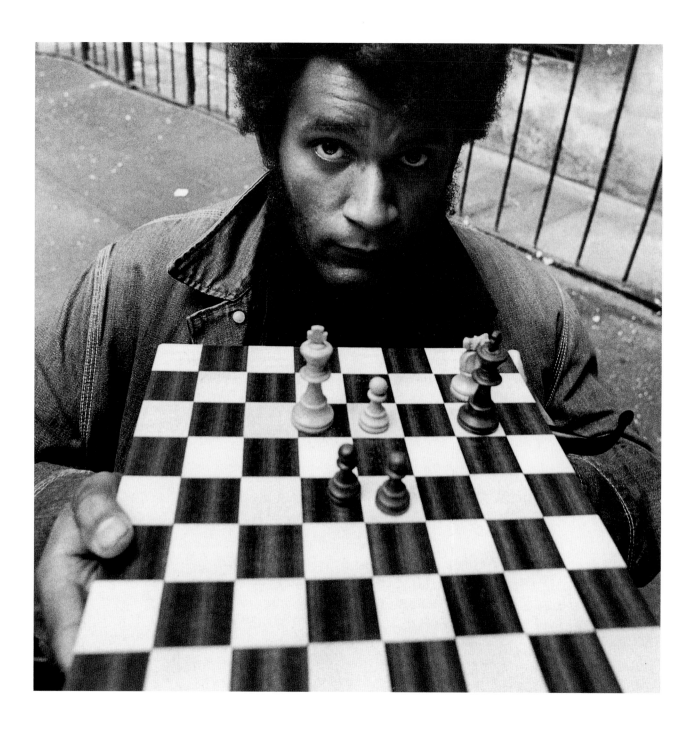

Anthony Braxton, 1971

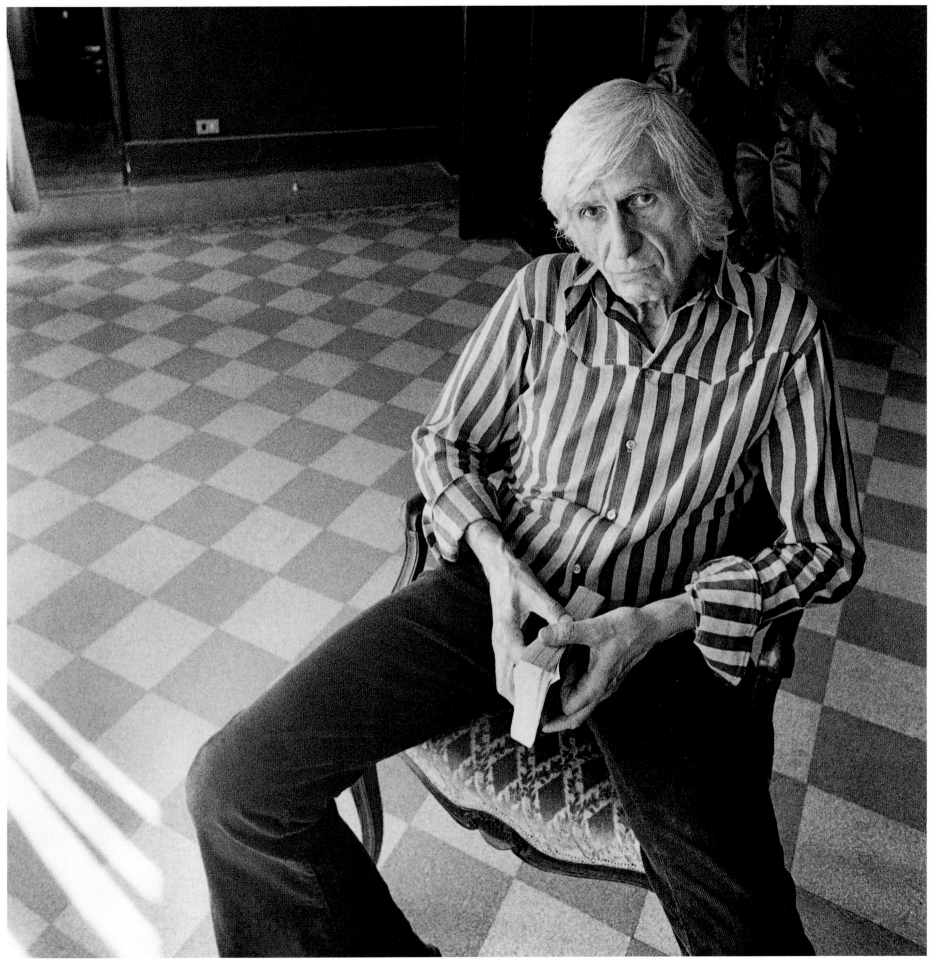

Gil Evans, 1974

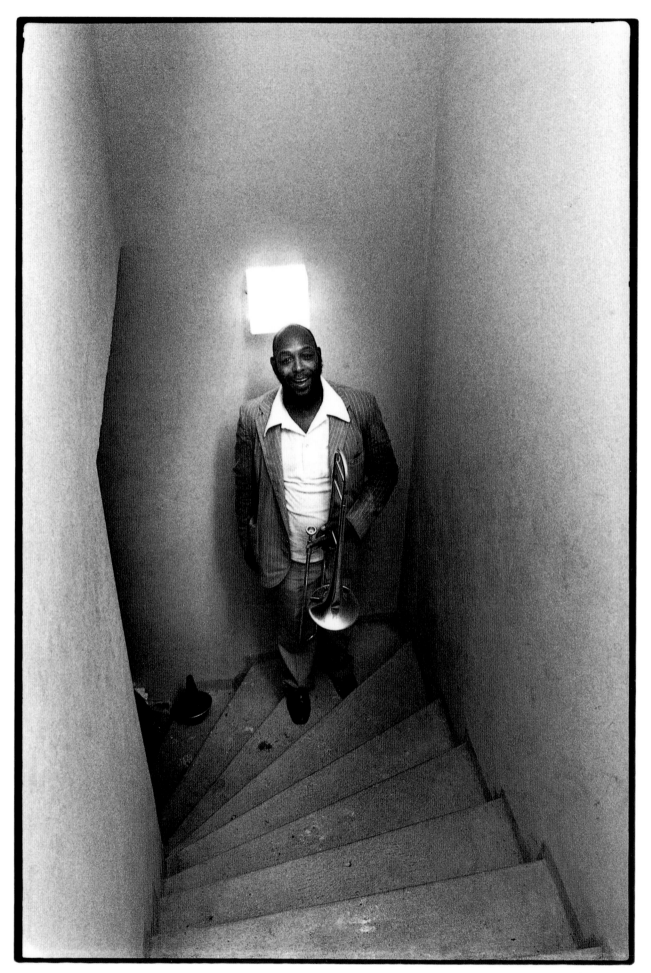

Charles Greenlee, 1975

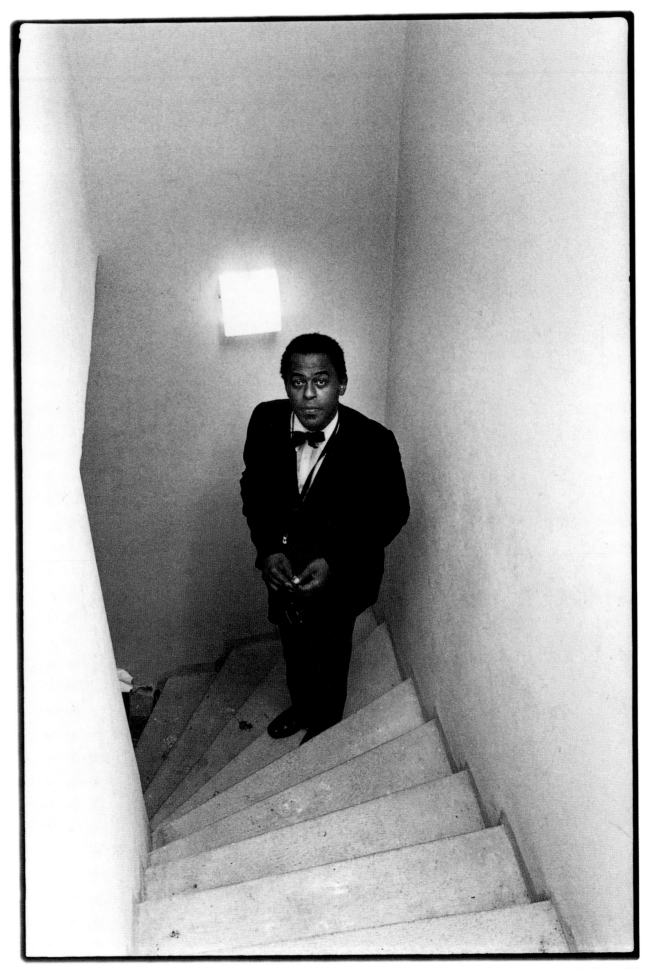

Archie Shepp, 1975

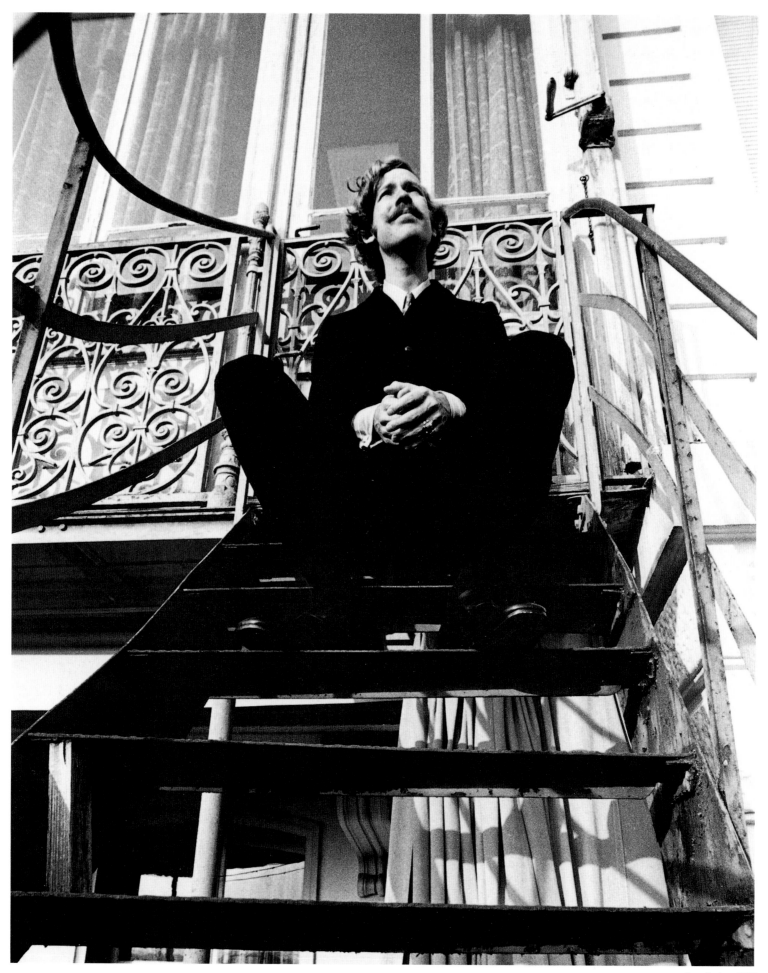

Gary Burton, 1968

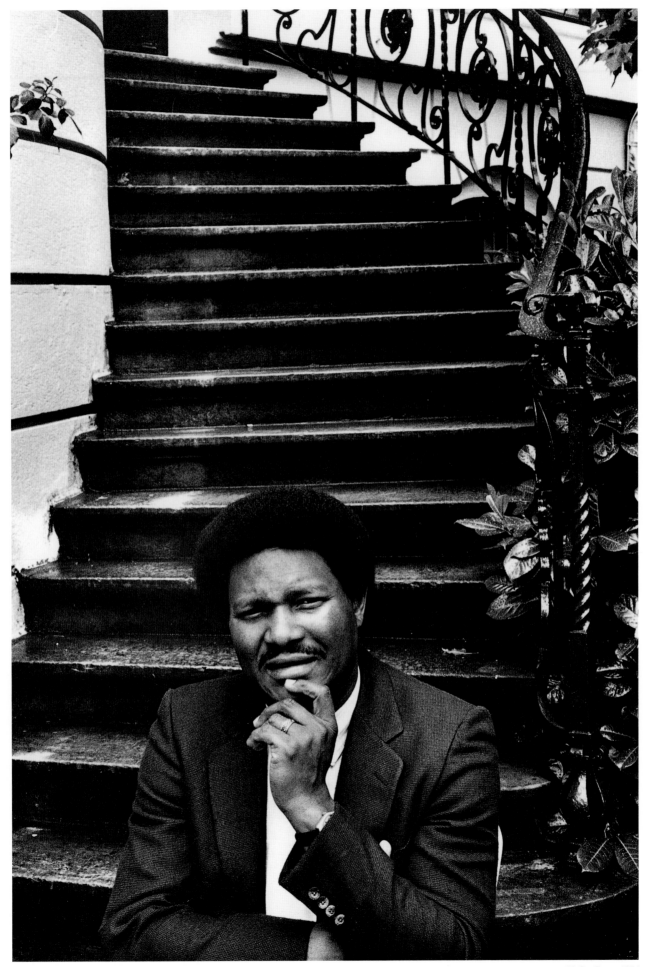

McCoy Tyner, 1981

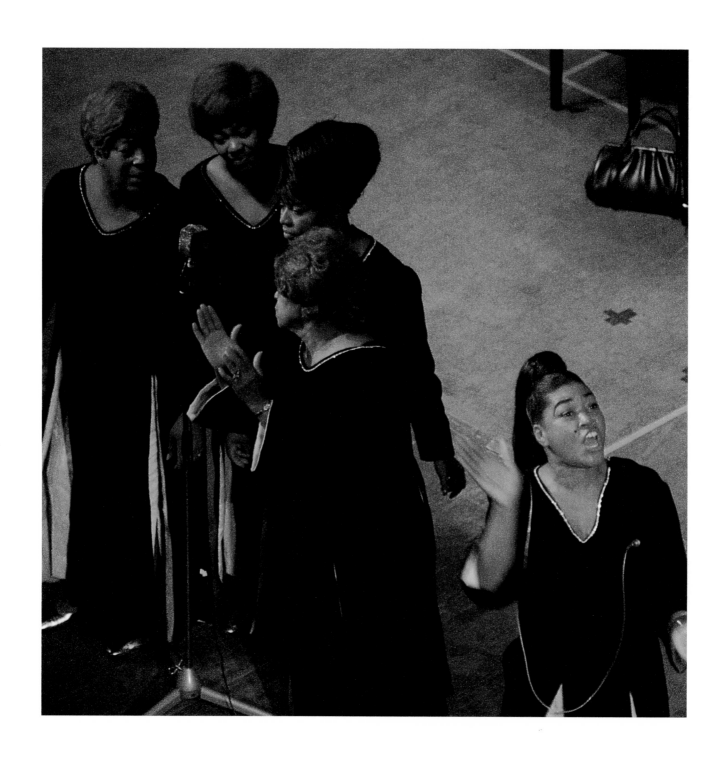

Stars Of Faith, 1974

Art Ensemble Of Chicago, 1973

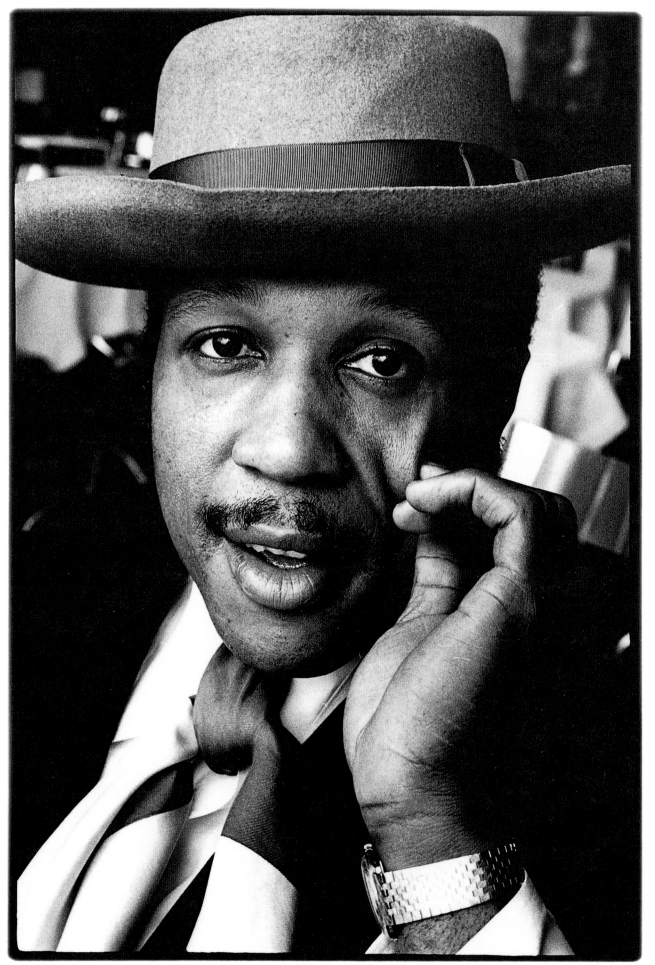

Les McCann, 1969

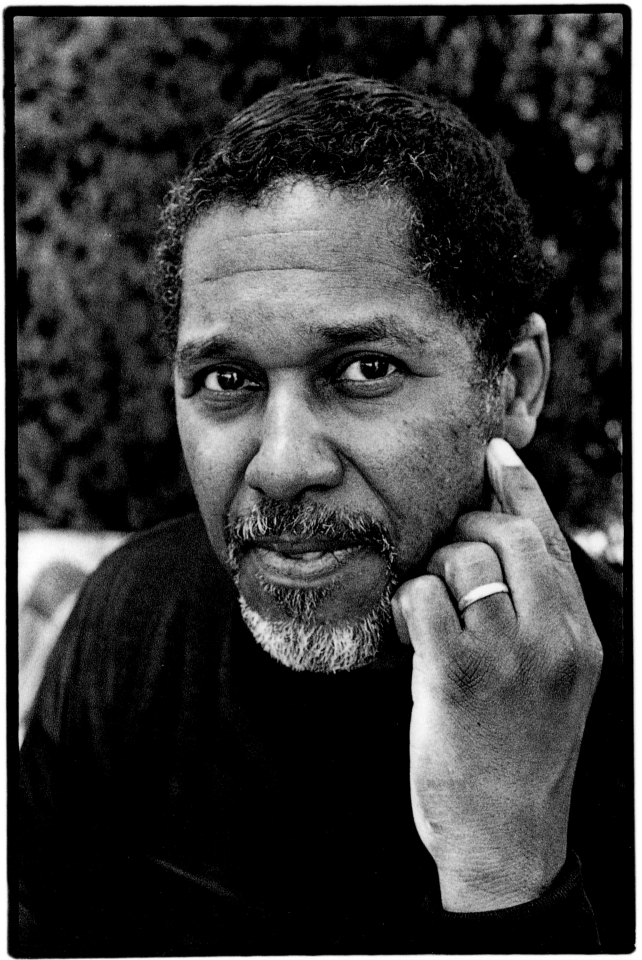

John Lewis, 1972

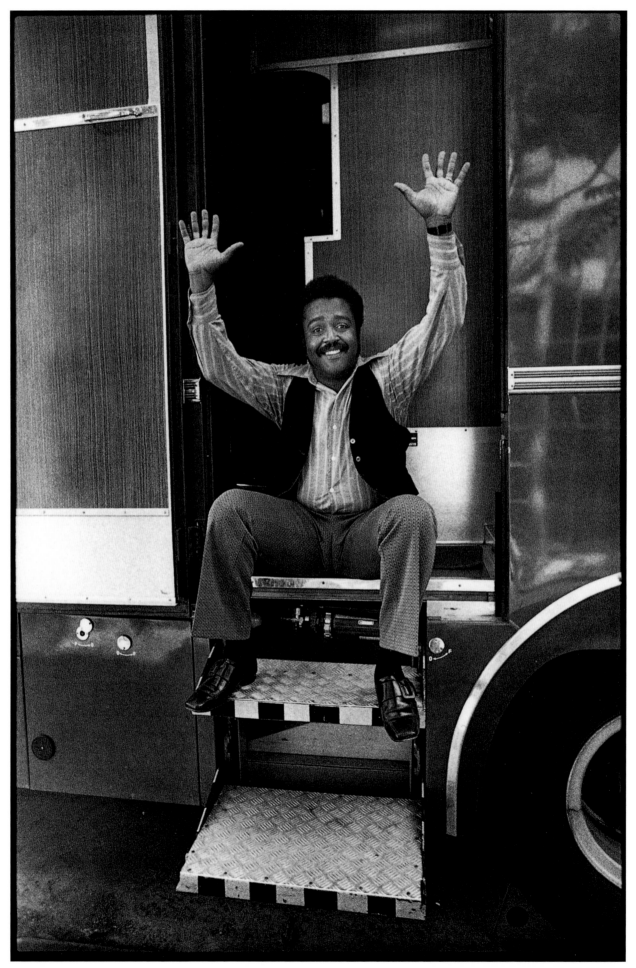

Ray Bryant, 1972

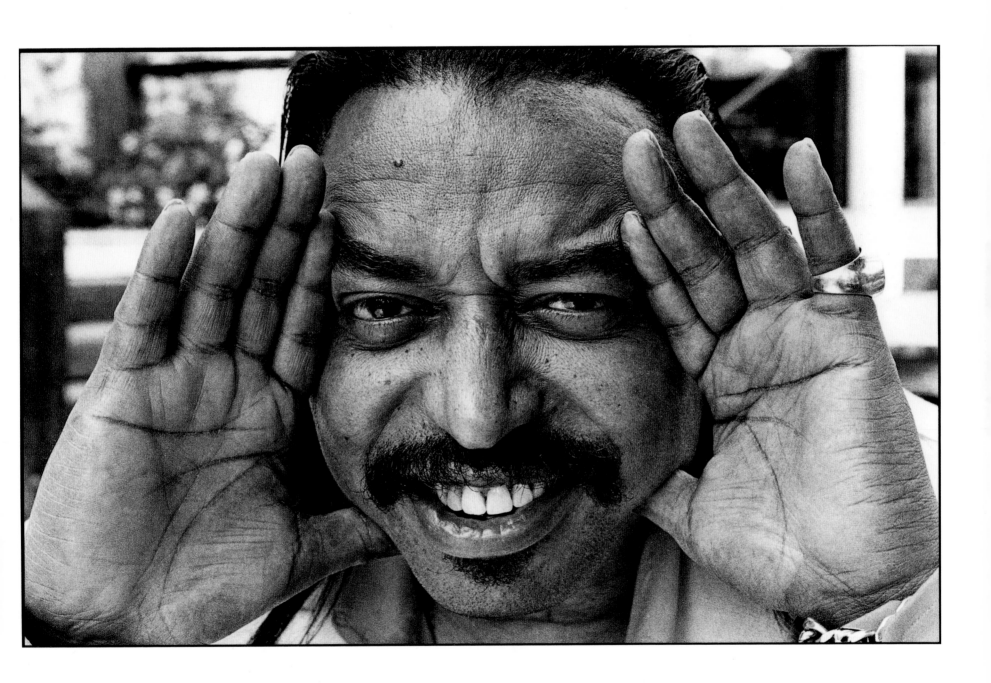

Chico Hamilton, 1971

Bob Stewart, 1981

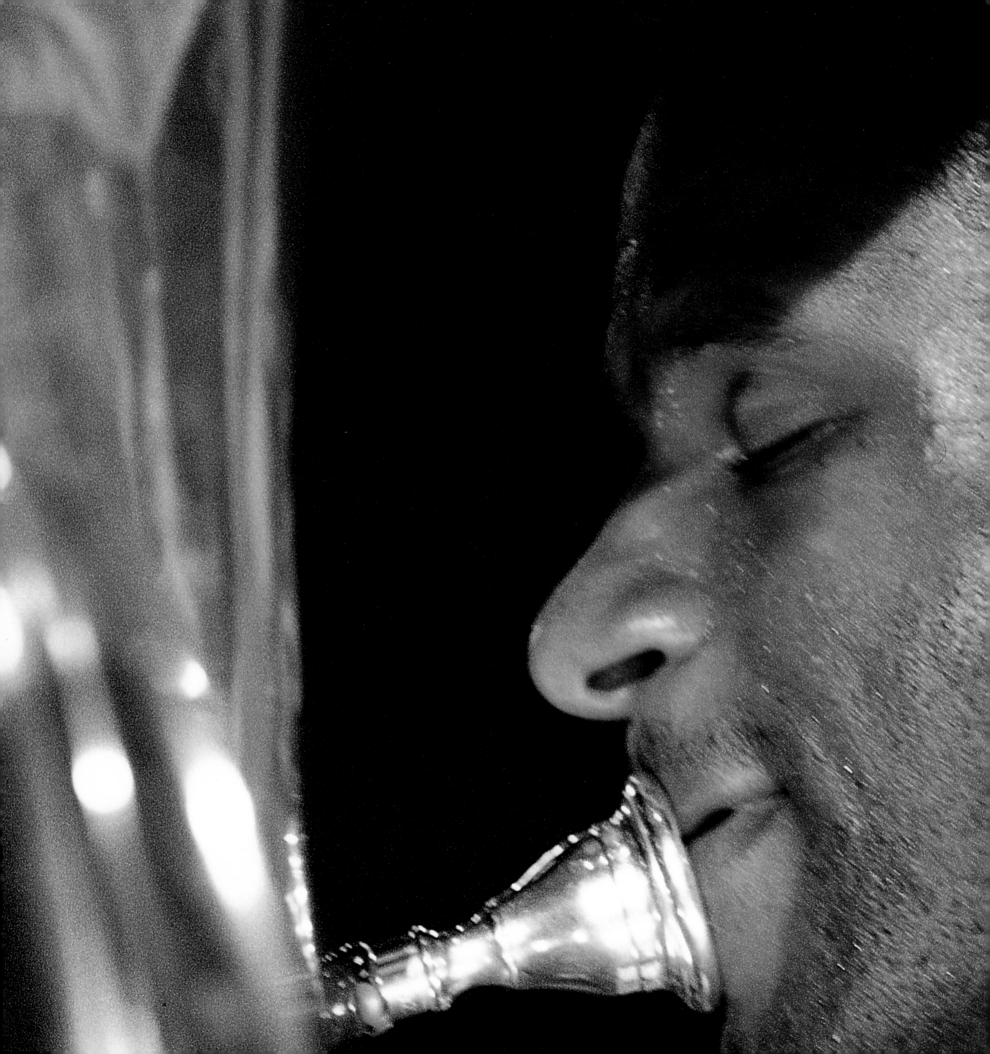

CD 1

SWING & JOY

1 SONNY ROLLINS ST. THOMAS *6:47*

(Rollins) Prestige Music
Sonny Rollins: tenor sax · Tommy Flanagan: piano · Doug Watkins: bass · Max Roach: drums
Recorded: June 22, 1956, New York · ℗ Fantasy, Inc. · ISRC US-FI8-56-00001

2 FREDDY HUBBARD JOY SPRING *6:47*

(Brown) copyright control
Freddie Hubbard: trumpet · Harold Land: tenor sax · Billy Childs: keyboards
Larry Klein: bass · Steve Houghton: drums · Buck Clark: Percussion
Recorded: December 14, 1981 · ℗ 1982 Pablo Records Tenth & Parker Berkeley · ISRC US-FI8-82-00011

3 STAN GETZ & HIS FOUR BROTHERS FIVE BROTHERS *3:12*

(Mulligan) Beechwood Music-BMI
Stan Getz, Zoot Sims, Al Cohn, Allan Eager, Brew Moore: tenor sax
Walter Bishop: piano · Gene Ramey: bass · Charlie Perry: drums
Recorded: April 8, 1949 · ℗ 1989 Fantasy, Inc. · ISRC US-FI8-49-00069

4 ZOOT SIMS FOUR I HEAR A RHAPSODY *5:33*

(Fragos, Baker, Gasparre) Thorn Creatives Int.-BMI
Zoot Sims: tenor sax · Richards Wyands: piano · Frank Tate: bass · Akira Tana: drums
Recorded: March 9, 1982, New York · ℗ 1982 Fantasy, Inc. · ISRC US-FI8-82-00262

5 DEXTER GORDON FRIED BANANAS *6:09*

(Gordon) Dex Music-BMI
Dexter Gordon: tenor sax · Barry Harris: piano · Buster Williams: bass · Albert "Tootie" Heath: drums
Recorded: April 4, 1969, Englewood Cliffs · ℗ 1994 Fantasy, Inc. · ISRC US-FI8-70-00167

6 MILT JACKSON & WES MONTGOMERY STABLEMATES *5:45*

(Golson) copyright control
Milt Jackson: vibes · Wes Montgomery: guitar · Wynton Kelly: piano · Sam Jones: bass · Philly Joe Jones: drums
Recorded: December 18&19, 1961, New York · ℗ Riverside · ISRC US-FI8-62-00118

7 DAVE BRUBECK QUARTET THE WAY YOU LOOK TONIGHT *7:45*

(Kern, Fields) Warner Bros. Music
Dave Brubeck: piano · Paul Desmond: alto sax · Ron Crotty: bass · Llyod Davis: drums
Recorded: March 2, 1953, Oberlin · ℗ 1987 Fantasy, Inc. · ISRC US-FI8-53 00072

CD 2

COOL & SOFT

1 MILES DAVIS QUINTET MY FUNNY VALENTINE *6:01*

(Rodgers, Hart) Chappell
Miles Davis: trumpet · Red Garland: piano · Paul Chambers: bass · Philly Joe Jones: drums
Recorded: October 26, 1956, New York · ℗ Prestige · ISRC US-FI8-56-00056

2 CHET BAKER HOW HIGH THE MOON *3:39*

(Hamilton, Lewis) Chappell Music
Chet Baker: trumpet · Herbie Mann: flute · Pepper Adams: baritone sax · Bill Evans: piano · Paul Chambers: bass · Connie Kay: drums
Recorded: December 30, 1958 & January 19, 1959, New York · ℗ 1987 Fantasy, Inc. · ISRC US-FI8-59-00043

3 RON CARTER ALL BLUES *8:43*

(Davis) Musical Frontiers-BMI
Ron Carter: piccolo bass · Kenny Barron: piano · Buster Williams: bass · Ben Riley: drums
Kermit Moore, Charles McCracken, John Abramowitz, Richard Locker: cellos ·
Recorded: December 1978, Englewood Cliffs · ℗ 2001 Fantasy, Inc. · ISRC US-FI8-80-00220

4 HERBIE MANN & BOBBY JASPAR TEL AVIV *14:42*

(Mann) Prestige Music-BMI
Herbie Mann, Bobby Jaspar: flutes, tenor sax · Tommy Flanagan: piano · Joe Puma: guitar · Wendell Marshall: bass · Bobby Donaldson: drums
Recorded: March 21, 1957, Hackensack · ℗ 1992 Fantasy, Inc. · ISRC US-FI8-57-00648

5 PAUL BLEY LIKE SOMEONE IN LOVE *4:07*

(Burke, van Heusen) Bourne/Music Sales Corp.-ASCAP
Paul Bley: piano · Charles Mingus, bass · Ark Blakey: drums
Recorded: November 30, 1953, New York · ℗ 1992 Debut Records, Fantasy, Inc. · ISRC US-FI8-54-00201

6 BILL EVANS TRIO SPRING IS HERE *5:06*

(Rodgers, Hart) Robbins Music-ASCAP
Bill Evans: piano · Scott Lafaro: bass · Paul Motian: drums
Recorded: December 28, 1959, New York · ℗ Fantasy. Inc. · ISRC US-FI8-60-00054

CD 3

CD 4

BLUES & CLASSICS

BOP & MORE

1 DUKE ELLINGTON C-JAM BLUES *5:14*

(Ellington) EMI Robbins Catalog-ASCAP
Duke Ellington: piano · Roy Burrowes, Cat Anderson, Bill Berry, Ray Nance: trumpets · Lawrence Brown, Leon Cox,
Chuck Connors: trombones · Russell Procope, Johnny Hodges: alto sax · Jimmy Hamilton: clarinet, tenor sax
Paul Gonsalves: tenor sax · Harry Carney: baritone sax · Aaron Bell: bass · Sam Woodyard: drums
Recorded: May 1, 1962, New York · ℗ 1984 Fantasy, Inc. · ISRC US-FI8-84-00109

2 JOE TURNER STORMY MONDAY *4:37*

(Walker) Gregmark Music-BMI
Joe Turner: vocals · Pee Wee Crayton: guitar · J. D. Nicholson: piano · Charles Norris: bass · Washington Rucker: drums
Recorded: March 3, 1975, Los Angeles · ℗ 1978 Pablo Records & Tenth and Parker · ISRC US-FI8-79-00307

3 COUNT BASIE JAM JUMPIN' AT THE WOODSIDE *4:32*

(Basie) Warner Bros. Music-ASCAP
Count Basie: piano · Vic Dickenson, Al Grey: trombones · Roy Eldridge: trumpet
Benny Carter: alto sax · Zoot Sims: tenor sax · Ray Brown: bass · Jimmie Smith: drums
Recorded: July 14, 1977, Montreux · ℗ 1977 Pablo Records & Tenth and Parker · ISRC US-FI8-77-00043

4 LOUIS ARMSTRONG MACK THE KNIFE *3:28*

(Brecht/Weill) Weill-Brecht-Harms-ASCAP
Louis Armstrong: trumpet, vocals · Trummy Young: trombone · Edmund Hall: clarinet
Billy Kyle: piano · Squire Gersh: bass · Barrett Deems: drums
Recorded: July 4, 1957, Newport · ℗ 1990 Fantasy Inc. · ISRC US-FI8-90-00022

5 OLIVER NELSON, KING CURTIS & JIMMY FORREST
BLUES AT THE FIVE SPOT *5:43*

(Nelson) Noslen Music-BMI
Oliver Nelson, King Curtis, Jimmy Forrest: tenor sax · Gene Casey: piano · George Duvivier: bass · Roy Haynes: drums
Recorded: September 9, 1960, Englewood Cliffs · ℗ 1992 Fantasy, Inc. · ISRC US-FI8-62 01134

6 ELLA FITZGERALD NIGHT AND DAY *6:59*

(Porter) Harms Inc.-ASCAP
Ella Fitzgerald: vocals · Tommy Flanagan: piano · Frank de la Rosa: bass · Ed Thipgen: drums
Recording: July 21, 1971, Nice · ℗ 1983 Pablo Records · ISRC US-FI8-83-00104

7 RAY BRYANT TAKE THE "A" TRAIN *4:06*

(Ellington, Strayhorn) Tempo Music-ASCAP
Ray Bryant: piano
Recorded: July 13, 1977, Montreux · ℗ 1977 Pablo Records Tenth & Parker · ISCR US-FI8-77-00001

8 OSCAR PETERSON & THE BASSISTS
SWEET GEORGIA BROWN *5:09*

(Bernie, Pinkard, Casey) Warner Bros.-ASCAP
Oscar Peterson, piano · Ray Brown: bass · Niels Pedersen: bass
Recorded: July 15, 1977, Montreux · ℗ 1977 Pablo Records Tenth & Parker · ISRC US-FI8-77-00203

1 WOODY HERMAN LA FIESTA *5:00*

(Corea) Litha Music-ASCAP
Woody Herman: clarinet, sax · Greg Herbert: sax, flute · Frank Tiberi, Steve Lederer, Harry Kleintank: sax
Larry Pyatt, Gil Rathel, Walt Blanton, Bill Byrne: trumpet · Bill Stapelton: trumpet, flugelhorn · Jim Pugh, Geoff Sharp, Harold Garrett: trombone
Andy Laverne: piano · Joe Beck: guitar · Wayne Darling: bass · Ed Soph: drums · Ray Barretto: conga
Recorded: April, 1973, New York · ℗ 1973 Fantasy Inc. · ISRC US-FI8-73-00429

2 ART BLAKEY & JAZZ MESSENGERS CARAVAN *9:45*

(Ellington, Mills, Tizol) American Academy of Music
Art Blakey: drums · Freddie Hubbard: trumpet · Curtis Fuller: trombone · Wayne Shorter: tenor sax
Cedar Walton: piano · Reggie Workman: bass
Recording: October 23&24, 1962, New York · ℗ 1987 Fantasy Inc. · ISRC US-FI8-62-00089

3 CHARLES MINGUS JUMP MONK *6:53*

(Mingus) Jazz Workshop-BMI
Charles Mingus: bass · Eddie Bert: trombone · George Barrow: tenor sax · Mal Waldron: piano · Willie Jones: drums
Recorded: December 23, 1955, New York · ℗ 1990 Fantasy, Inc. · ISRC US-FI8-56-00093

4 DIZZY GILLESPIE MANTECA *9:26*

(Gillespie, Fuller) Music Sales Corp.-ASCAP
Dizzy Gillespie, trumpet · Toots Thielemans, guitar · Bernard "Pretty" Purdie, drums
Recorded: July 19, 1980, Montreux · ℗ 1981 Fantasy Inc. · ISRC US-FI8-81-00032

5 McCOY TYNER AFRO BLUE *9:58*

(Santamaria) Mongo Music–BMI
McCoy Tyner: piano · Sonny Fortune: soprano & alto sax, flute · Virgil Jones, Cecil Bridgewater, Jon Faddis: trumpets
Dick Griffin, Garnett Brown: trombones · Kiani Zawadi: euphonium · Julius Watkins, Willie Ruff, William Warnick III: French horns
Bob Stewart: tuba · Hubert Laws: piccolo, flute · Harry Smyles: oboe · Selwart Clarke, John Blair, Sanford Allen, Winston Collymore,
Noel DaCosta, Marie Hence: violins · Julien Barber, Alfred Brown: violas · Ronald Lipscomb, Kermit Moore: cellos
Jooney Booth: bass · Alphonse Mouzon: drums · Sonny Morgan: congas
Recorded: April 6-9, 1973, New York · ℗ 1991 Fantasy Inc. · ISRC US-FI8-73-00124

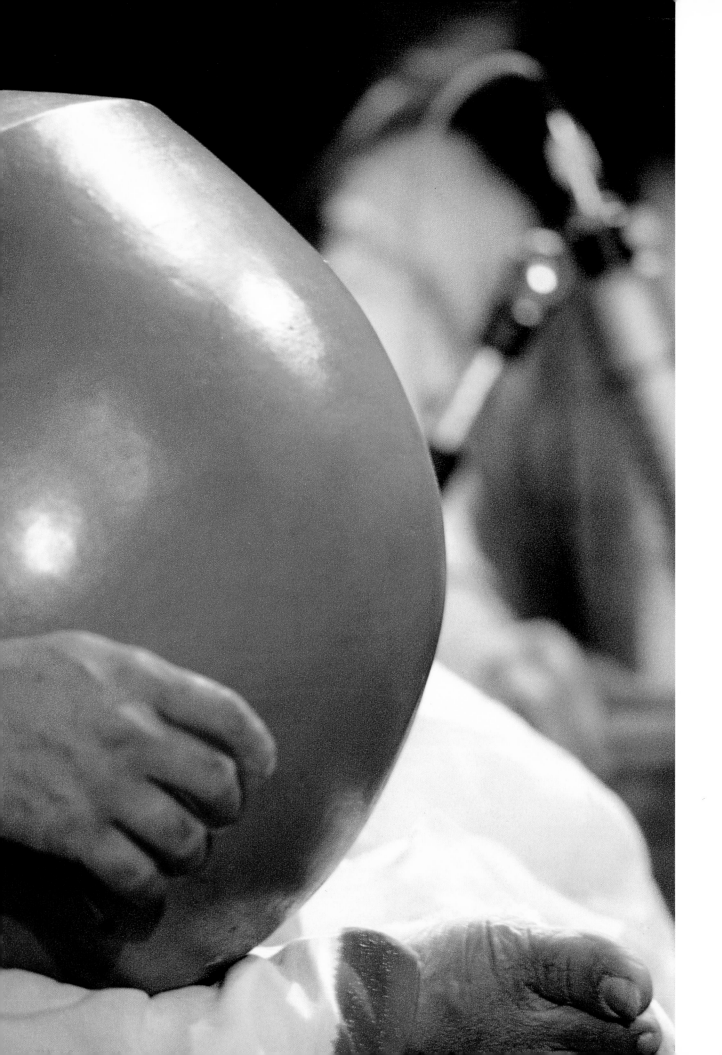

Shakti, 1976